WHAT TO PAINT

BOATS & HARBOURS
IN ACRYLIC

Dedication
I'd like to dedicate this book to my dear old Mum,
who kept saying, 'This one is taking some time.
Will I get to see it before I croak it?'

WHAT TO PAINT

BOATS & HARBOURS
IN ACRYLIC

Charles Evans

SEARCH PRESS

First published in Great Britain 2015

Search Press Limited
Wellwood, North Farm Road,
Tunbridge Wells, Kent TN2 3DR

ISBN: 978-1-84448-958-9

The Publishers and author can accept no responsibility for any consequences arising from the information, advice or instructions given in this publication.

Suppliers
If you have any difficulty obtaining any of the materials and equipment mentioned in this book, please visit the Search Press website:
www.searchpress.com

Printed in China

Acknowledgements
I'd like to thank Winsor & Newton for their continued support and supply of the best art materials any artist could wish for. What a lucky boy I am!

Thanks also to Edd the editor for deciphering my text and coming up with a great layout.

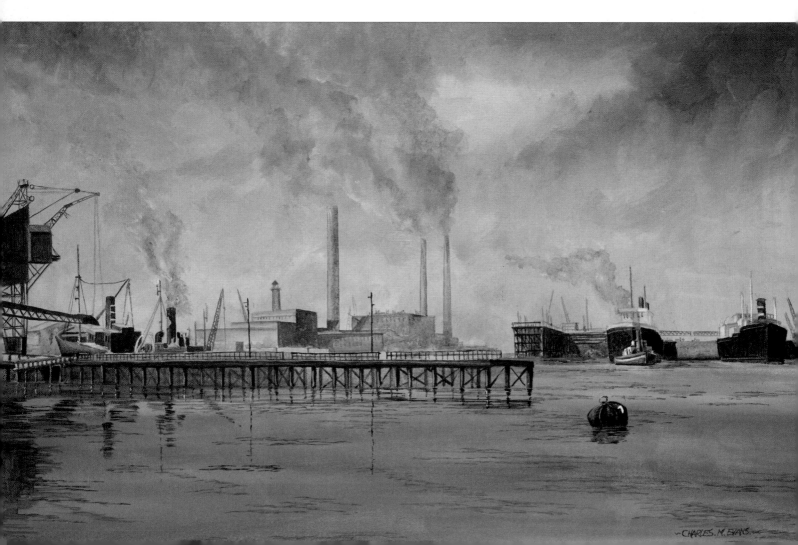

CONTENTS

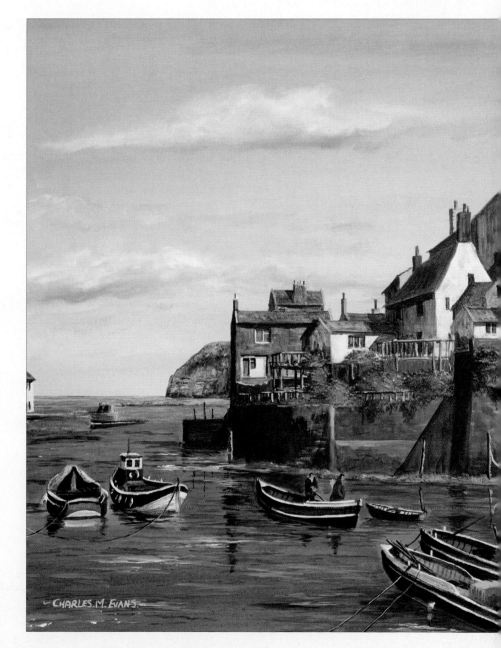

INTRODUCTION

There is no end of inspiration for painting boats or harbours in coastal Northumberland, UK, where I live; but in this book I wanted to show the amazing diversity of boats that can be seen in different countries. To that end, I have included images from around the world. I felt that simple compositions limited to 'boat, harbour, and a bit of water' would be slightly monotonous, so I have included a wide variety of images, from rowing boats in the river Seine amidst the beauty of Paris, to icebreakers against a cold and desolate Russian backdrop.

With an artist's eye, you tend to see things slightly differently. I suppose we genuinely see things, rather than just look at them. My friends will regularly realise that I have stopped listening because I've started looking – so I have heard the phrase 'oh ignore him, he's an artist' many times! Really, the artist's eye is a good excuse to stand and stare.

The shape of a boat can be a very daunting one and people are often scared when coming to paint or draw them. Here you will see them at all different angles, shapes and sizes which will hopefully make it easier for you rather than trying to imagine the shapes.

Each of the paintings in this book is accompanied by a list of the paint colours I used, as well as a little background information about the painting and the inspiration behind it. Alongside each painting you will see various sections pulled out and highlighted. These are either parts of the painting with which I was particularly happy, or were of great importance to the composition of the picture.

Remember that a nice painting does not have to be complex and cluttered. We are painters, not photographers, so you do not have to stick rigidly to what is in front of you – feel free to move things around slightly and change the composition to suit you. Whenever I am away from home, I always have a sketchbook to hand somewhere or, as a last resort, my trusty camera phone because inspiration for a painting is always close at hand no matter where you may be. Effectively, you can think of this book as your own sketchbook, with the inspiration just waiting to be put on canvas.

Using the outlines contained in this book is not like painting from photographs. Rather, they are seeing a composition through an artist's eyes. In other words, the scene is already made up in order to – hopefully – inspire you to have a go.

This book will show you an easy way to transfer the images on to paper without the need to tear the outlines from the book, and there is advice on enlarging the outlines for the more adventurous. You are at liberty to change the composition, add to the paintings, or combine elements from one to another.

Finally, this book is not full of pretentious artistic terminology. It reads how I speak and how I see things. I hope you enjoy using it as much as I enjoyed my journey throughout the paintings.

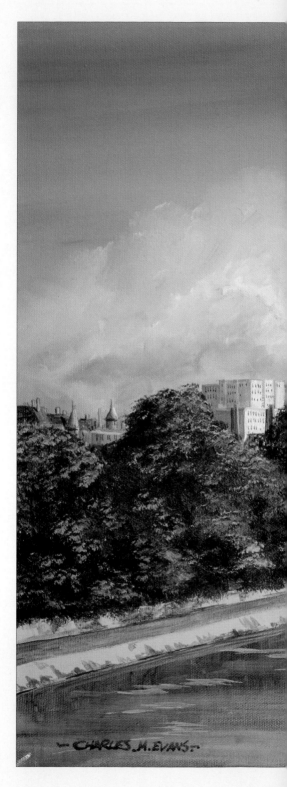

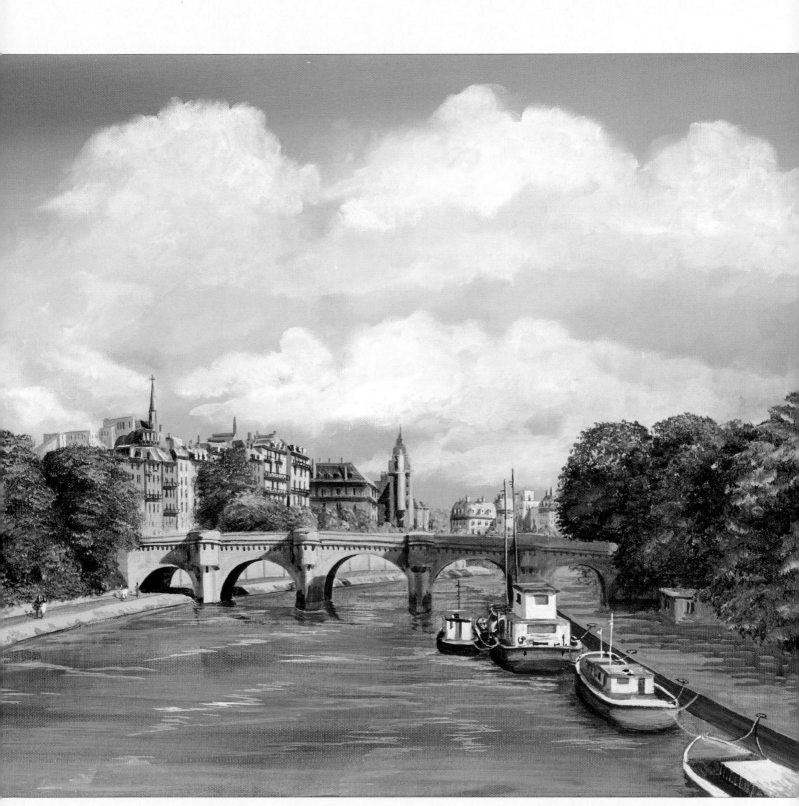

This project, *Paris*, appears on pages 44–45.

THE PAINTINGS

Staithes, page 16

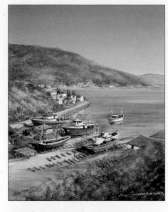

Greek Boatyard, page 18

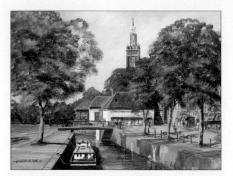

Edam, page 20

Polperro, page 22

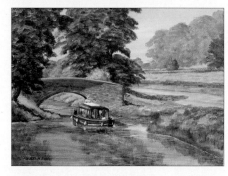

Narrowboat Holiday, page 24

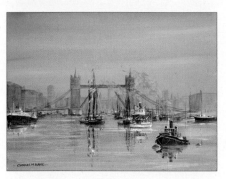

River Pageant, page 26

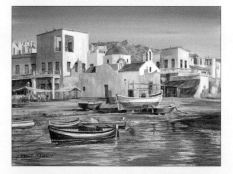

Mykonos, page 28

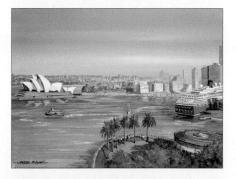

Sydney Opera House, page 30

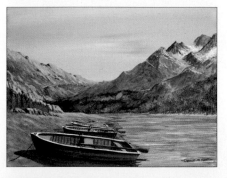

Swiss Rowing Boats, page 32

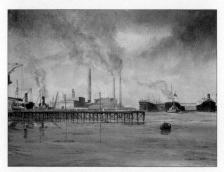

Blyth Harbour, page 34

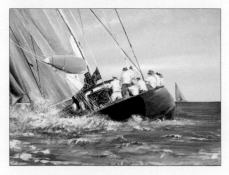

Racing Yacht, page 36

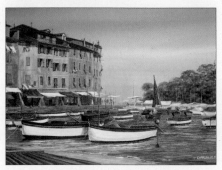

Mediterranean Port, page 38

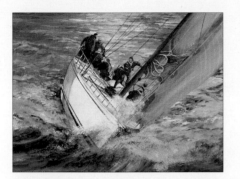

Racer, page 40

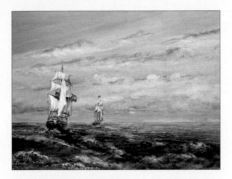

The Tall Ships, page 42

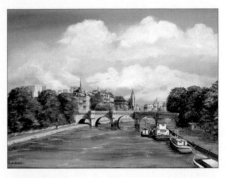

Paris, page 44

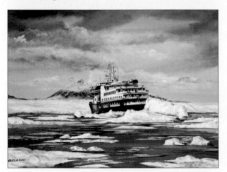

Russian Icebreaker, page 46

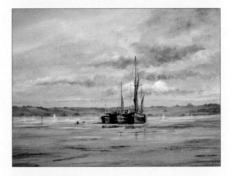

Pin Mill, page 48

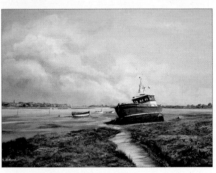

Alnmouth, page 50

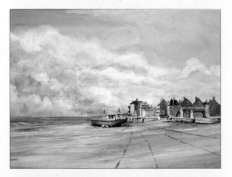

Aldburgh, page 52

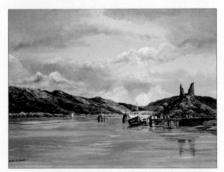

Maol Castle, page 54

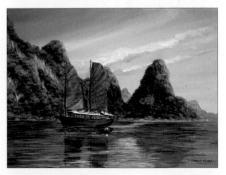

Thailand Junks, page 56

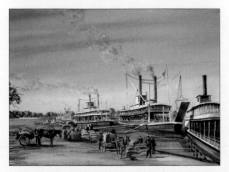

Mississippi Riverboats, page 58

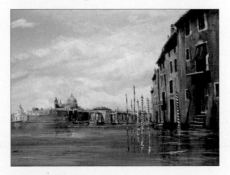

Venice, page 60

Tobermory, page 62

TRANSFERRING THE IMAGE

You do not need to remove the outlines from the book to transfer them on to your painting surface if you follow the methods shown below. You can also photocopy or scan the outlines, enlarge them to the size you want and then transfer them as shown.

Using tracedown paper

This is an easily available paper for transferring images, sometimes known as graphite paper, and is similar to the carbon paper that was used in the days of typewriters.

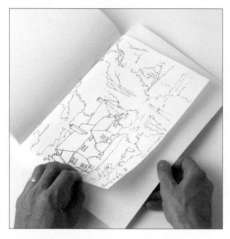

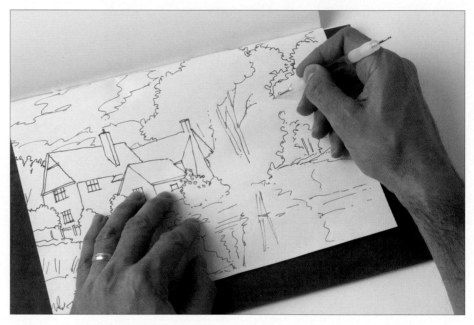

1. Slip your painting surface – such as watercolour paper, canvas or canvas effect paper – directly under the outline you want to use. You may need to tear out the outline if you wish to use a box canvas.

2. Slip a sheet of tracedown paper between the outline and the painting surface. Go over the lines using a burnisher.

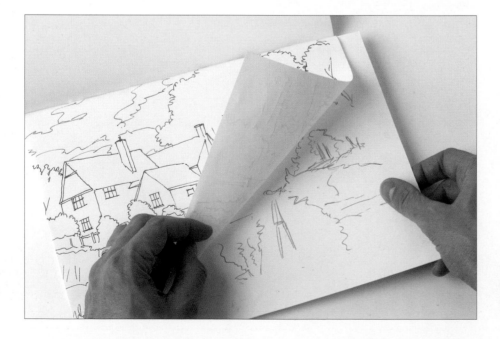

3. Remove the tracedown paper and lift up the outline to reveal the image transferred on to your painting surface, ready for you to begin painting.

Using pencil

1. Turn to the back of the outline you want to transfer. Scribble over the back with a soft pencil.

2. Turn the page so that you are looking at the image you want to transfer. Place your painting surface underneath the page. Go over the lines with a burnisher.

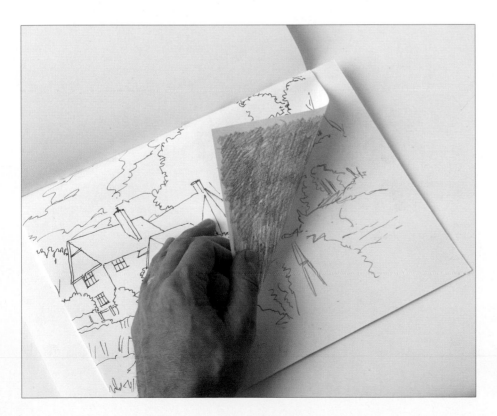

3. Lift the page to reveal the image transferred on to your painting surface. When you remove the painting surface, make sure you put a piece of scrap paper in between this outline and the next to avoid graphite from the back of the page transferring on to the next outline.

HOW TO USE THIS BOOK

You can reproduce the paintings in this book just like I have painted them, using the outlines and the advice with each project. However, you may want to branch out and adapt the paintings to your own taste. You could take one element from an outline and place it in a different background, or use exactly the same outline but paint the scene in a different season, or in a different colour scheme.

You may want to work on a larger scale, in which case you can easily photocopy or scan an outline and then enlarge it to the size you prefer.

In a few of the paintings, particularly in the close-up sections, you will see the grain of the canvas, which is always a nice effect. But although I have used canvas on which to paint, remember that all of the techniques in the book can also be used on a decent heavyweight watercolour paper. The only wet into wet techniques that have been used have been in some of the sky washes and the skies were always finished whilst good and wet. Quite often, for a lot of the clouds, I have put the paint on the canvas with a large brush and then worked the painting with my fingers to form the shape of clouds. In a lot of instances I have simply merged all the colours in together whilst it was all still very wet on the canvas.

This tranquil panorama is made by using just the top part of *Greek Boatyard*, shown on pages 18–19. This makes an alternative little composition with a nice route leading from the white buildings in the foreground, past the poplars into the bay and out into the distant headlands. This makes a very pleasing composition for one of those days when you do not want to think about boats. If you choose this alternative composition, keep the warmth of the original flooding in throughout the painting. Just the kind of thing to paint on a cold winter's day at home.

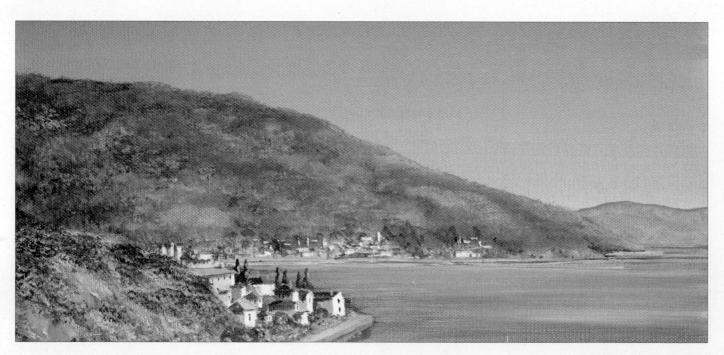

In this alternative composition of *Staithes* (see pages 16–17), we are making the most of the edge of this very strong building, high on its perch, along with the lovely distance of the cliff face and the sea.

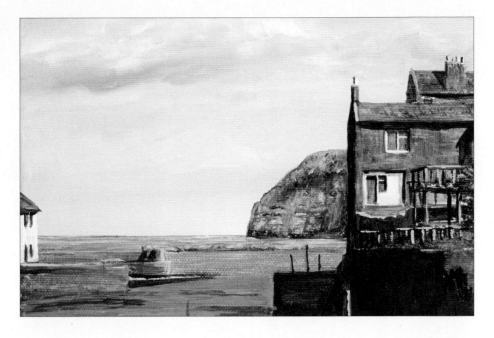

Focusing on the riverside of *Paris*, shown on pages 44–45, turns the boat scene of the original into a beautiful landscape by the Seine.

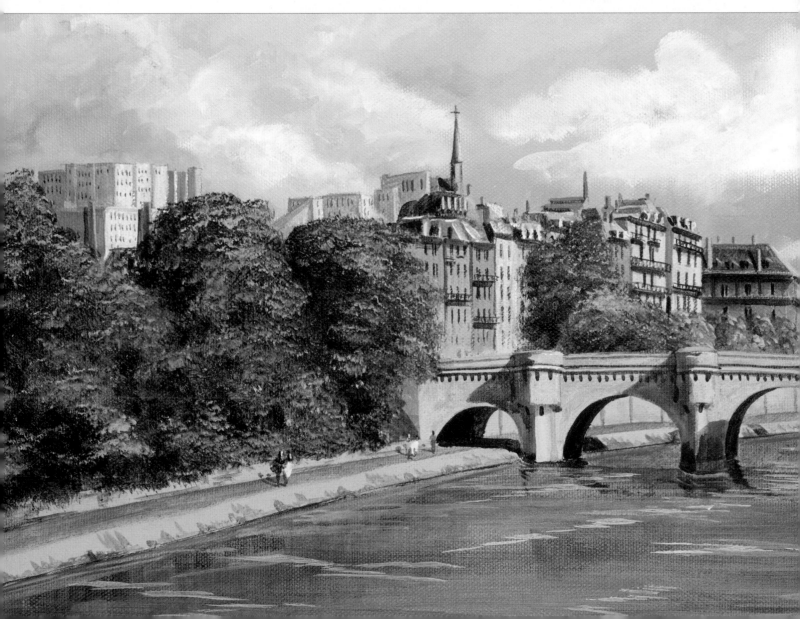

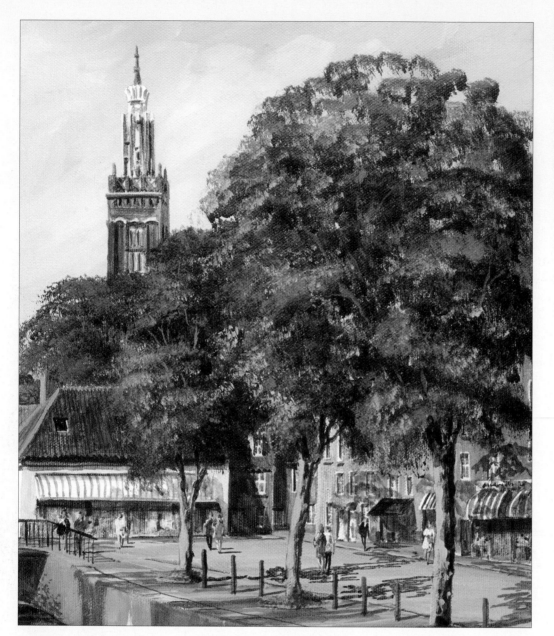

Dutch Square

This alternative composition of *Edam* (see pages 20–21), concentrates on the intimate little market square with shops, people and recession created by the trees and also good strong shadow and light.

It has a totally different feel to the one with the canal in it, as the church spire is now prominent on the left-hand side of the painting. This is a little picture with plenty of depth, shape and atmosphere.

PAINTING BOATS

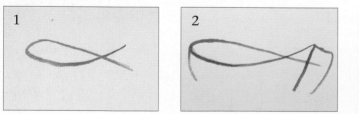

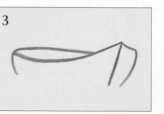

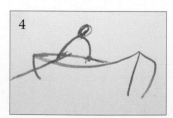

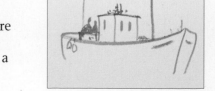

The shape of a boat can be a daunting one, but there's always an easy way. Paint a simple fish, as in figure 1. Put a stick on the end of the tail, a bit for the front and a bit for the back and you have the basic shape for a boat, as in figure 2. Erase the overlapping line, as in figure 3, and you have a boat.

This can be used as the basis for a great many types of boat. Place a little figure into it, as in figure 4, and you have a rowing boat. Make the stroke coming downwards longer, put a little box and a couple of masts on top and you have a fishing boat, as in figure 5. Don't be scared, painting boats can be rewarding.

BRUSHES AND COLOURS

All of the paintings in this book have been painted on canvas using the Winsor & Newton Artists' acrylic range, in the colours listed in the box to the right. Before I started each painting, I pre-stained the canvas with raw sienna. In thinner, washed areas – for example in some of the skies – you will see this glowing through here and there because a lot of the Winsor & Newton Artists' acrylics have a transparent quality.

In some of the paintings you will see some very dark areas, which one assumes is black. I never use a manufactured black as I often find them to produce flat, dead results. The easiest ways to make a nice black with the colours I suggest is to mix either Payne's gray with burnt sienna or ultramarine blue with burnt sienna.

In every painting, whichever blue I have chosen for the sky is the blue which is carried throughout the rest of the painting for anything natural, such as the water, blues in trees or grasses, or shading. For anything man-made within the picture, it does not really matter which blue you use, but to change your blues within the same picture for anything natural will tonally unbalance the painting.

PALETTE OF COLOURS

Cobalt blue
Ultramarine blue
Prussian blue
Winsor blue
Burnt sienna
Raw sienna
Raw umber
Buff titanium
Titanium white
Naples yellow
Hooker's green
Alizarin crimson
Payne's gray
Cadmium red

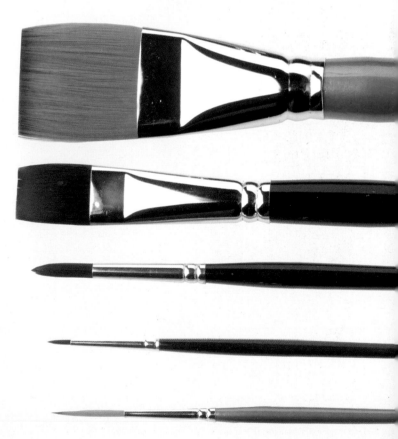

The 37mm (1½in) flat brush is the brush that I use for all of my sky washes. It covers a lot of area quickly. Quite often, for a lot of the clouds, I have put the paint on the canvas with this brush and then worked the painting with my fingers to form the shape of clouds.

The 25mm (1in) flat brush is used for laying paint down on mid-sized areas, such as walls of buildings. I also use its sharp edge for details such as ripples and waves.

I use a size 8 round brush for the majority of the hulls of the boats and similar large areas that need a little more precision than is easily possible with the 25mm (1in) flat brush.

The size 2 round brush is used for people, windows and other fine details. It is a sturdy little brush that holds lots of paint.

The size 3 rigger brush is a brush invented for painting rigging, so that is just what I use it for!

STAITHES

Staithes is a little fishing port on the east coast of the UK, not so far away from where I live. It is a scene that I have known since childhood and one that I revisit frequently because it has so many fabulous paintable views. I chose this particular scene for its relative simplicity and because it is a classic 'L' formation landscape, with the buildings tumbling down to the water which in turn lead you off to the distance.

On the day that I sketched this, the light was streaming in from the right and the two fishermen in the boat were having a difficult job trying to get to their mooring spot. This gave way to some hilarious banter and I remember one of them calling to me 'I hope you're not putting this in,' to which I replied, 'No, I only paint nudes.'

PALETTE OF COLOURS

Cobalt blue

Titanium white

Raw umber

Alizarin crimson

Hooker's green

Burnt sienna

Naples yellow

Buff titanium

Payne's gray

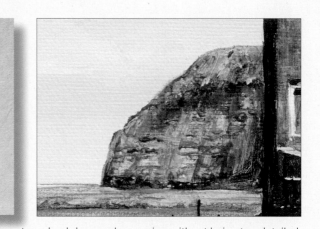

This important cliff creates a backdrop and recession without being too detailed. Using my size 8 round brush I painted the whole block with raw umber, then stippled on a mixture of Hooker's green and burnt sienna at the top section only. After washing the brush out thoroughly, I went into the washed areas with a stronger mix of raw umber with a touch of Payne's gray added to it, to create a rocky textured effect to this block. Finally, still using the same brush, I stippled a little Naples yellow into the grassy bits, to add a little bit of light.

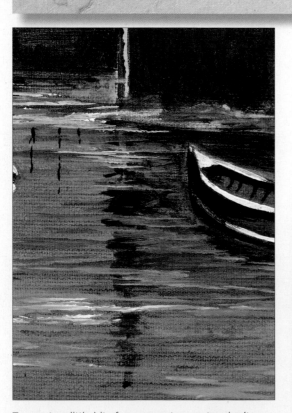

To create a little bit of movement on water, don't make your reflections perfect mirrors. To that end, this is a squiggly broken line of reflection using the same strong dark mix of raw umber mixed with Payne's gray, as was used to paint the building.

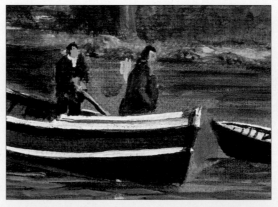

In the overall composition, the two fishermen in the boat appear complex, but when highlighted you see that they are just a couple of blobs and nothing to worry about. I used my size 2 round brush for these, with a mix of buff titanium with a hint of burnt sienna mixed in for the flesh tone. The man on the right-hand side has a green coat on, for which I used a mixture of Hooker's green with raw sienna. The one on the left was raw umber mixed with a touch of titanium white. Notice the highlight around his neck – just a bit of titanium white, and the shadowing and hair was just Payne's gray. How fortunate they were black-haired sailors!

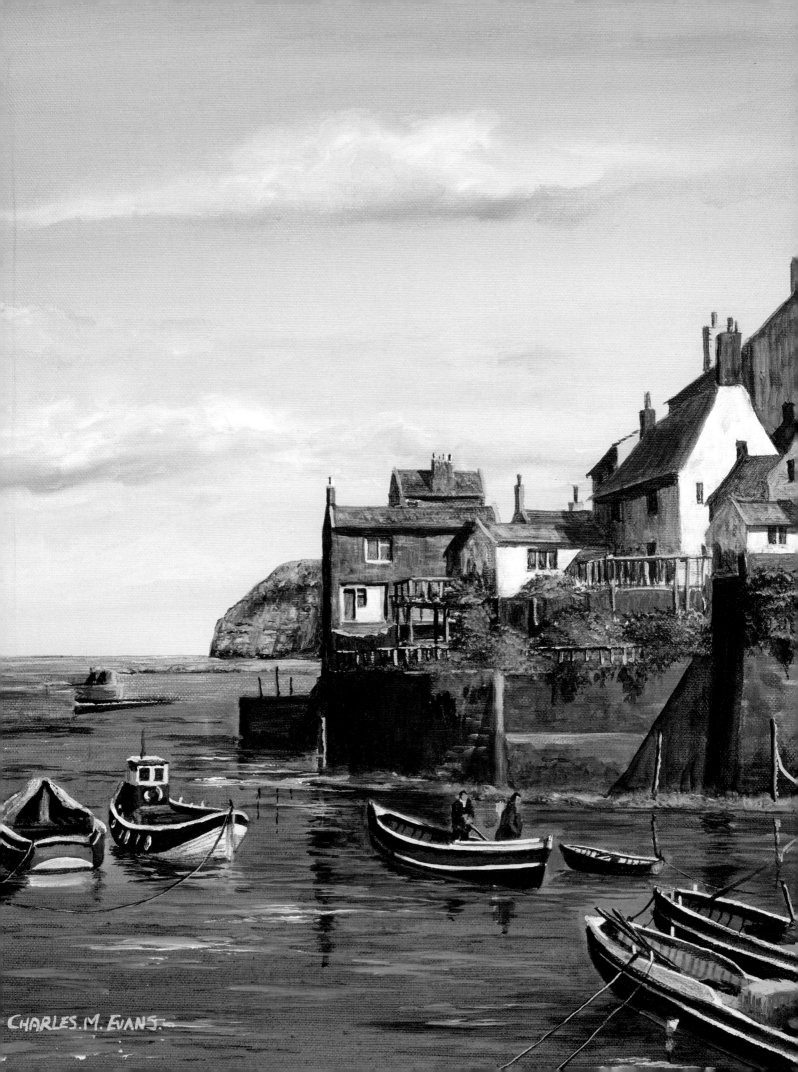

CHARLES.M.EVANS.

GREEK BOATYARD

This is a good old-fashioned Greek boatyard made up from a mix of photographs taken and sketches made while I was out there. Good strong bright light, without a cloud in the sky, was the order of the day. In a painting like this there is always plenty of recession both in scale and in tone. The only real challenge to an artist in a scene like this is to try and capture the warmth and atmosphere of the place.

A painting like this always grabs me because it is like a good book, it has a beginning, a middle and an end: in this case, strong foreground, middle distance and recession. To sit on a hillside bathed in the warm glow capturing a breathtaking, yet busy little scene was truly rewarding.

Tip
For white in shadow, add a hint of blue for a cool shadow.

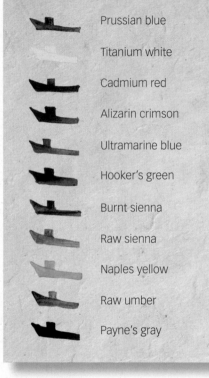

PALETTE OF COLOURS

Prussian blue

Titanium white

Cadmium red

Alizarin crimson

Ultramarine blue

Hooker's green

Burnt sienna

Raw sienna

Naples yellow

Raw umber

Payne's gray

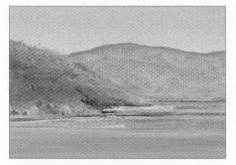

An important part of this picture is on the right-hand side of the canvas, where the distant background starts to frame the grassy hill in front of it. In a painting like this, even the distant colours have to have warmth, and for this I have used my 25mm (1in) flat brush with a mixture of Prussian blue and a tiny touch of alizarin crimson. I added plenty of water into this mix and the transparent layer shows a touch of my understained raw sienna showing through.

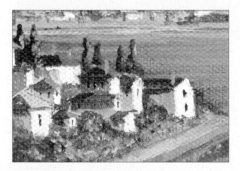

I used my size 8 round brush for this village section, using titanium white for the bright side of the buildings and a hint of Prussian blue mixed with titanium white for the darker side of the buildings. For the roofs I used burnt sienna for the darker sides and burnt sienna with a touch of titanium white mixed in for the lighter sides. For the poplars, Hooker's green mixed with Prussian blue for the darker sides and then I added a little bit of Naples yellow to the green for the lighter sides. The windows are just simple strokes of Payne's gray. At this distance you do not need to see details. Notice that the reflection below is just an intimation of what is above using the same colours, not a perfect mirror image.

In the overall scheme of the painting, this distant area is clearly a village, but on closer examination you see that it is just a few white blobs with some burnt sienna here and there, with touches of blue to highlight darker sections of the buildings – basically a few dabs of paint that come together to suggest a village. For all of this I used my size 2 round brush.

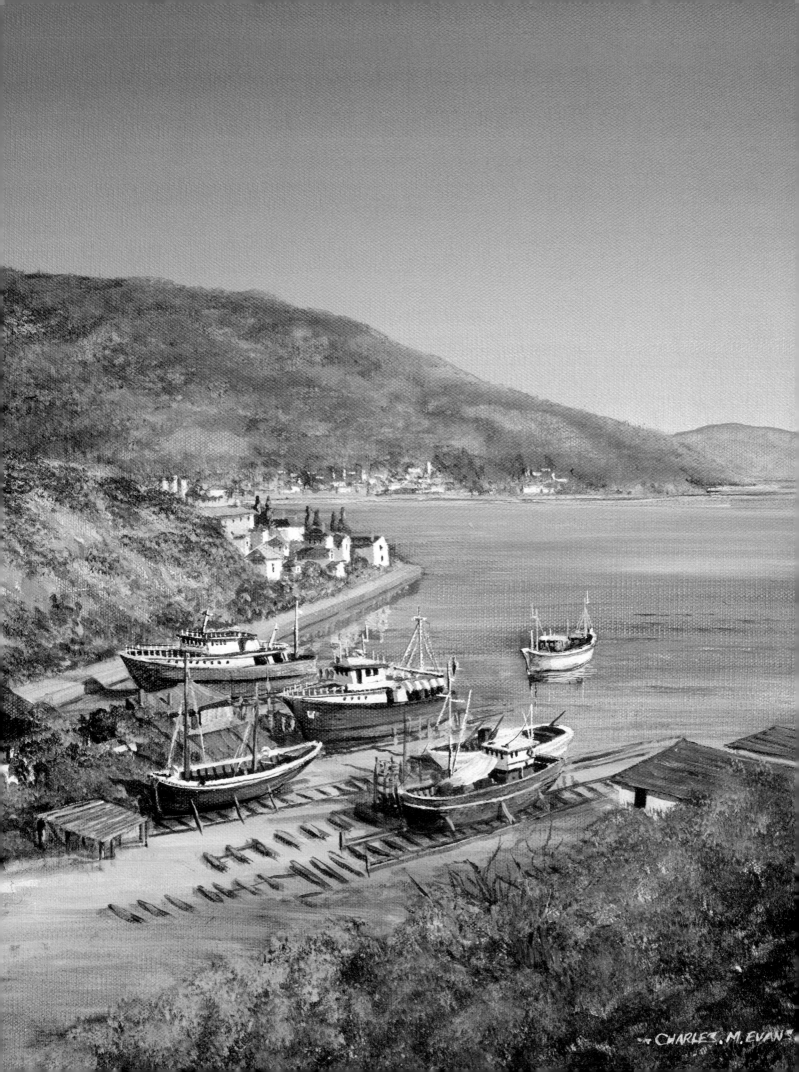

EDAM

This painting of Edam, in Holland, has a particular Dutch feeling, created by the shape and type of buildings and, of course, the canal. The trees on the right of the painting provide a sense of recession. Starting from the big prominent one in the foreground, the trees get progressively smaller to the distant ones behind the building. The church spire adds a lovely prominent vertical to the whole composition.

It was not a particularly warm day when I was there, and so I created a blustery sky with cobalt blue and titanium white followed by short stabbing strokes of titanium white using my 37mm (1½in) flat brush.

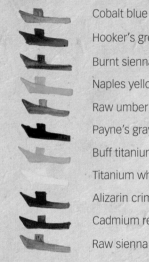

PALETTE OF COLOURS

Cobalt blue

Hooker's green

Burnt sienna

Naples yellow

Raw umber

Payne's gray

Buff titanium

Titanium white

Alizarin crimson

Cadmium red

Raw sienna

The shadows cast by the big tree to the left-hand side add shape to the canal walls coming up to the horizontal ground above, and also serve to add a little texture to the otherwise blank stone wall. I used my 25mm (1in) flat brush with a mix of the same blue as the sky – cobalt blue – plus alizarin crimson and a touch of burnt sienna. Notice that there are a few strokes of well watered-down titanium white here and there as well. Using light against dark like this is a neat little trick for contrast. Do not labour over a section like this: use bold, broad strokes.

The spire adds a powerful vertical to the painting. I used my size 2 round brush and well watered-down Payne's gray and blended in just a tiny touch of titanium white to the left-hand side. The large section below this was added with titanium white and the same brush, then a little bit of raw umber and Payne's gray was worked in vertical strokes to create the ribs coming up on the right-hand side. I changed to my size 8 round brush for the main body of the spire and used a mixture of raw umber and burnt sienna, creating the shading here and there with Payne's gray. Add a touch of cobalt blue to the mix for the windows.

I have to confess to making this lady's pink skirt slightly shorter than it was! I used alizarin crimson with a touch of titanium white for the pink, and a simple mix of buff titanium with a touch of burnt sienna for the flesh tone. The important part of all the figures in the painting is what ties them to the ground: the shadow. For this I used the same mixture as I used for the canal wall: cobalt blue plus alizarin crimson and a touch of burnt sienna.

To give the trees depth, I first painted on the foliage using mixtures of Hooker's green and burnt sienna and Hooker's green and raw sienna, followed by a little bit of Naples yellow. All the paint is applied fairly dry, using the 25mm (1in) flat brush, which I split by plunging it head first into the paint and then stippling the colours on top of one another. Once complete, I used the size 3 rigger brush to paint a few light twigs on top of the dark. This gives highlights and a bit more of a three-dimensional effect.

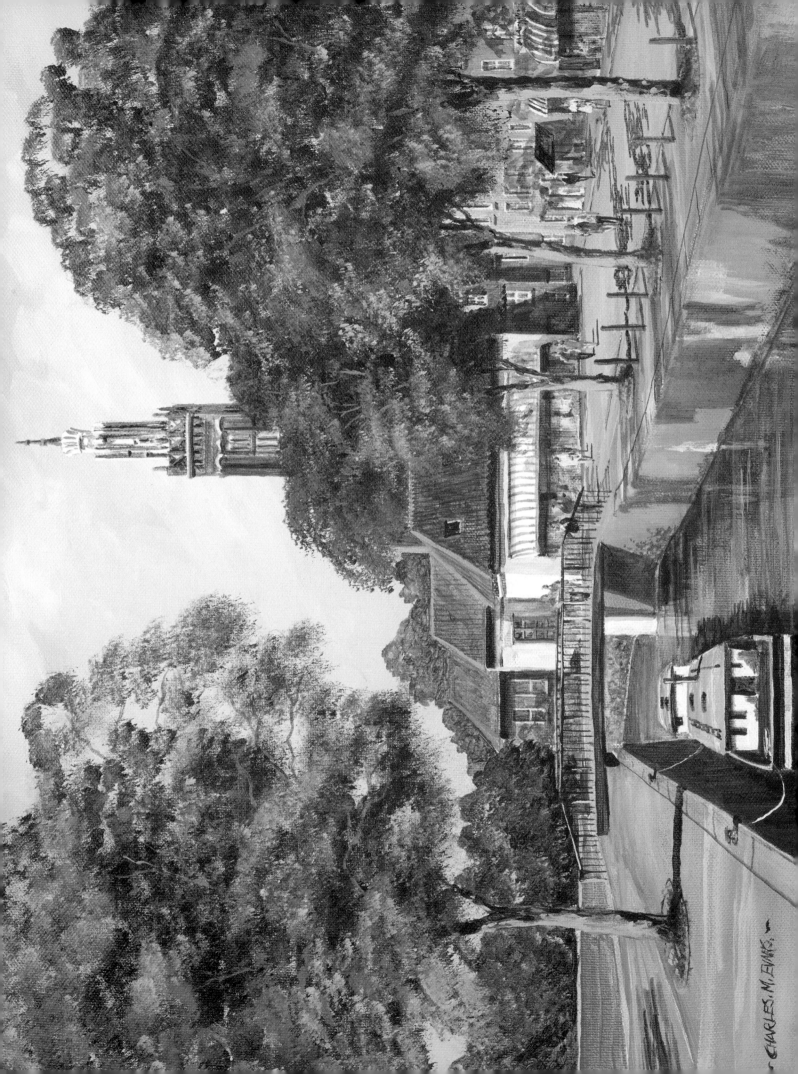

POLPERRO

Polperro is a lovely iconic Cornish port and one I remember visiting as a boy in short trousers. Happy days, when the summer was always hotter, the sea was always warm and Christmas trees always seemed far bigger than they do today. Polperro's beauty surpassed my memories when I revisited it recently and did a couple of watercolour sketches from various angles. It is one of those little fishing villages that is always busy and crowded, yet full of inspiration.

The challenge here is to see through the clutter and crowds and paint the bits that are vital to the painting. That is exactly what I have done for you here in this picture: Polperro, without the clutter and crowds.

PALETTE OF COLOURS

Prussian blue

Titanium white

Buff titanium

Alizarin crimson

Cobalt blue

Naples yellow

Hooker's green

Burnt sienna

Raw umber

Cadmium red

Payne's gray

Raw sienna

For the flesh tone here I have used buff titanium with a tiny touch of alizarin crimson. Painting something very light within a darker area, as in this example of the two people standing forward from the dark shadows of the building, helps to create an extra feel of light. Importantly, one of the figures has a bright white shirt on. This trick of adding strong contrast here and there in a painting with light against dark is always effective and does not have to be with people.

Always have a little shadow between anything leaning against something else, to make one stand forward from the other and prevent them merging together. These ladders leaning against the harbour wall are a typical example. For this I used my size 2 round brush, the harbour wall itself was raw umber with a few darker areas of raw umber mixed with Payne's gray. The ladder was raw umber with a few strokes of raw umber mixed with buff titanium for the lighter sections and the shadow was the blue of my sky, Prussian blue mixed with alizarin crimson and burnt sienna.

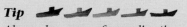

Tip
Always be aware of your direction of light, so that you paint the shadow in the right direction. In this case, the light is coming from the right.

For this section I painted the tree in mixtures of Hooker's green and burnt sienna, followed by Payne's gray here and there. I next painted the hill using mixtures of Hooker's green, raw sienna and burnt sienna. Touches of Naples yellow, stippled on using my split 25mm (1in) flat brush, serve to split the tree from the hill by knocking the tree behind the hill.

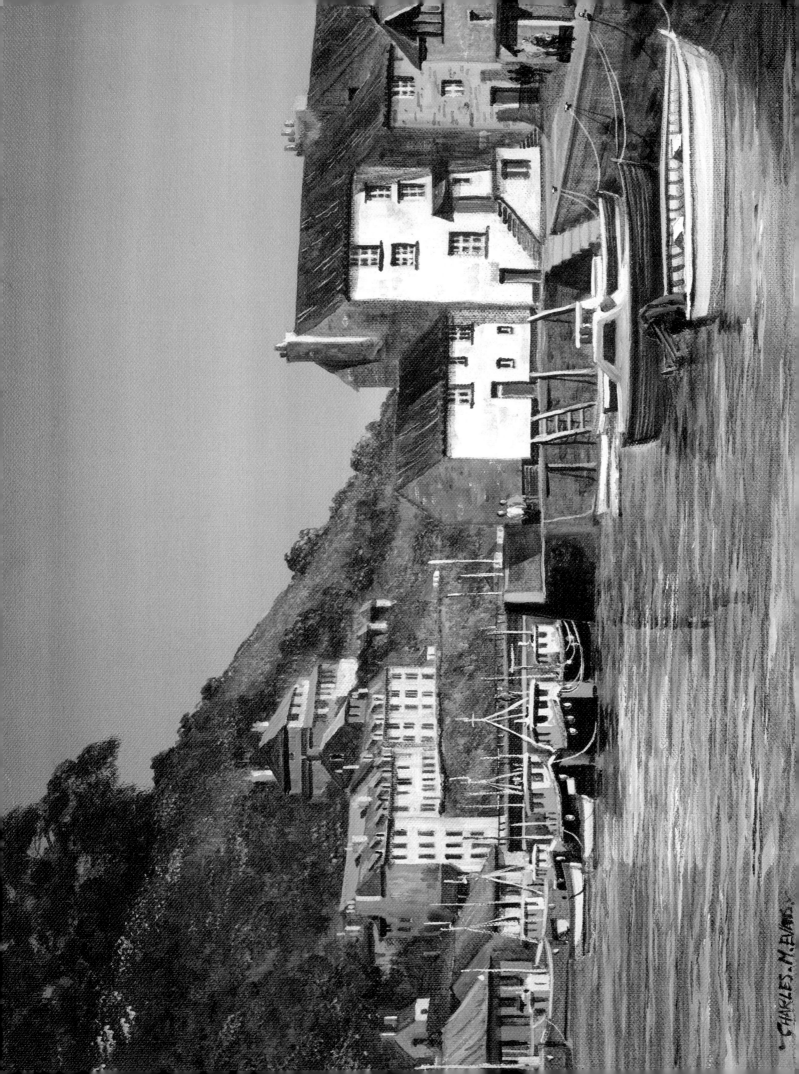

CHARLES. M. EVANS

NARROWBOAT HOLIDAY

This painting aims to evoke the feelings of wonderful warm summer days on the English canals, using good strong colours and deep greens with peaceful, still waters. A painting like this will always remind me of lazy, hazy summer days on a traditional English narrowboat in the British countryside. I tried to create depth with the contrast of the strong greens of the foreground trees compared to the warm mistiness of the distant trees. The strength of this painting is the bridge, with its mellow stone and good dark contrasting shadow.

PALETTE OF COLOURS

Cobalt blue

Hooker's green

Raw sienna

Burnt sienna

Raw umber

Naples yellow

Alizarin crimson

Payne's gray

Titanium white

Buff titanium

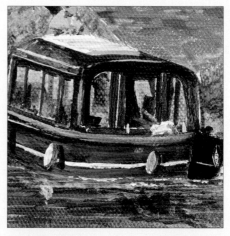

I created depth in the water by dragging the colours used in the grass downwards to create a still reflection. I left a little bit of light between land and reflection, then used my 25mm (1in) flat brush to glaze over the dried greens with a mix of cobalt blue and a touch of titanium white. Once this had dried I then used my size 8 round brush to paint a few squiggly lines here and there to create interest and light to the top of the water. Painting a few strokes of light across the darkness of the reflection will always create more depth.

Notice how strong the foreground trees are in comparison to the distant trees. For the foreground trees that you see protruding here from the left, I used Hooker's green and burnt sienna and then a few touches of Payne's gray for more strength. Now look how much further back the comparatively lighter green of Hooker's green and Naples yellow mixed go. To accentuate this even further I used strong light in the fields underneath the trees: this is primarily Naples yellow with a few touches of burnt sienna here and there for added warmth. I then broke up those fields with the strength of the hedges, this time using Hooker's green mixed with cobalt blue.

To avoid the barge's windows looking flat and boring, it is nice to see inside as well. To achieve this, using my size 8 round brush, I painted some random shapes within the window shape with just Payne's gray. Once this had dried I then glazed over the area with a well watered-down mixture of Payne's gray and cobalt blue. All this helps to create just that little bit more depth.

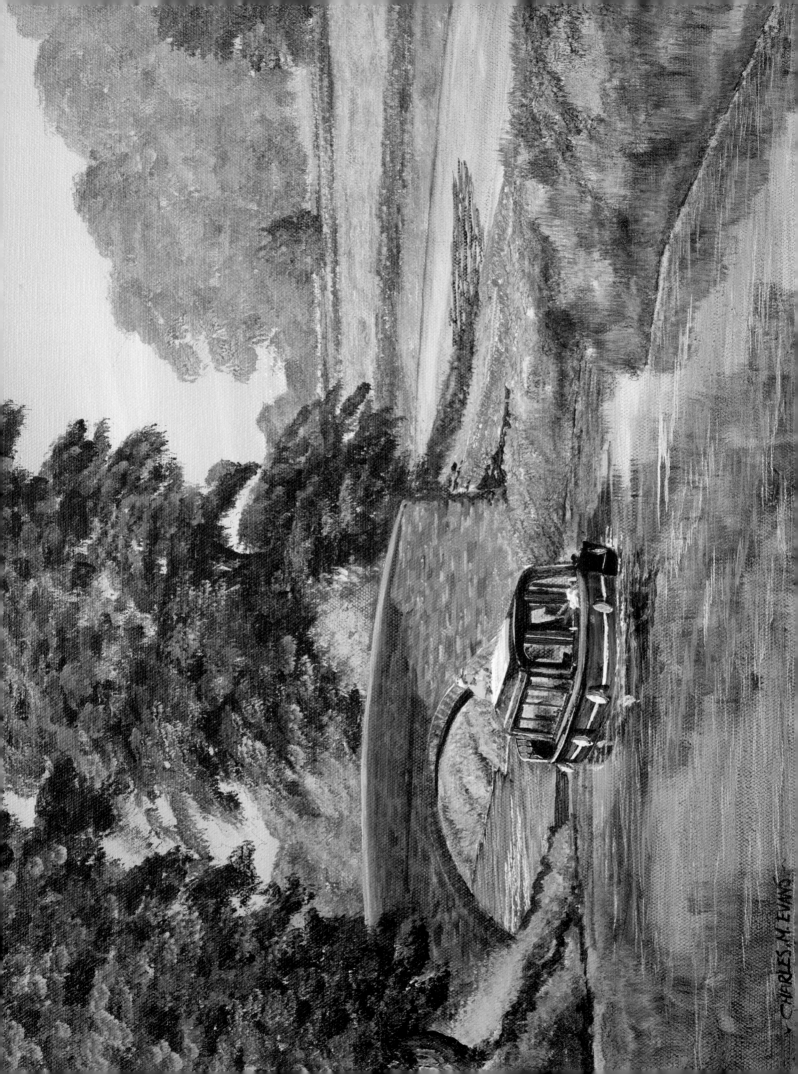

RIVER PAGEANT

This painting of Tower Bridge in the distance was inspired by photographs taken at the preparation for the river pageant for the Queen's Diamond Jubilee in 2012. Although Tower Bridge is a very imposing and important landmark, for the purposes of this painting I have made it sit very much in the distance as I wanted to create an overall feel of hazy mistiness to the entire painting, contrasted against the crisp freshness of the boats in the foreground.

Painting a scene anywhere in London can be a very daunting prospect, yet treating it like this can simplify it enormously without any detriment to composition.

PALETTE OF COLOURS

Cobalt blue

Titanium white

Payne's gray

Alizarin crimson

Raw umber

Raw sienna

Naples yellow

Burnt sienna

Hooker's green

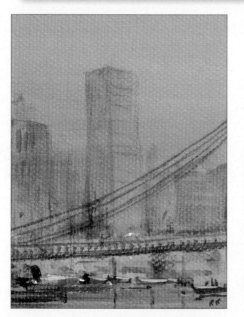

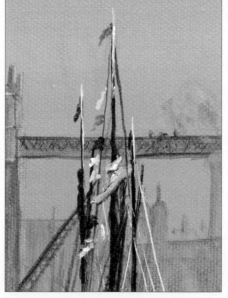

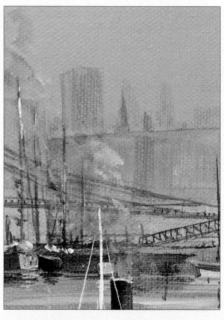

These buildings are easy. This tower, for instance, is a very simple block painted with my size 8 round brush in a mix of raw umber and titanium white, with the addition of a little bit of cobalt blue here and there for a few darker touches. I then dragged a few horizontal lines of cobalt blue through the building to give the impression of lots of floors. Notice these strokes do not look blue. That is because it is fairly weak paint going straight on top of the other, still wet, layer of paint.

For obvious reasons, lots of the boats had bunting on them when I prepared this painting. Rather than trying to paint furrows and other fiddly details in the flags, I simplified them to just a few daubs of colour using the tip of my size 8 round brush. I'm sure there must be a nautical term for all of these flags, and I'm sure there will be some sailors out there saying that the message does not read anything. Who cares? I'm an artist.

I always paint smoke coming from chimneys – whether on boats or buildings – once everything else is finished. This stage can be scary as you are painting on top of everything you have already put down on the canvas, but by doing it this way you are able to see through the smoke to the image behind. Make sure the rest of the picture is completely dry, then prepare a mixture of Payne's gray and titanium white. Using a size 8 round brush, start from where the smoke comes out of the top of the chimney and literally just roll the brush up the canvas in the direction you want the smoke to travel. While still wet, drop in a few touches of raw umber here and there.

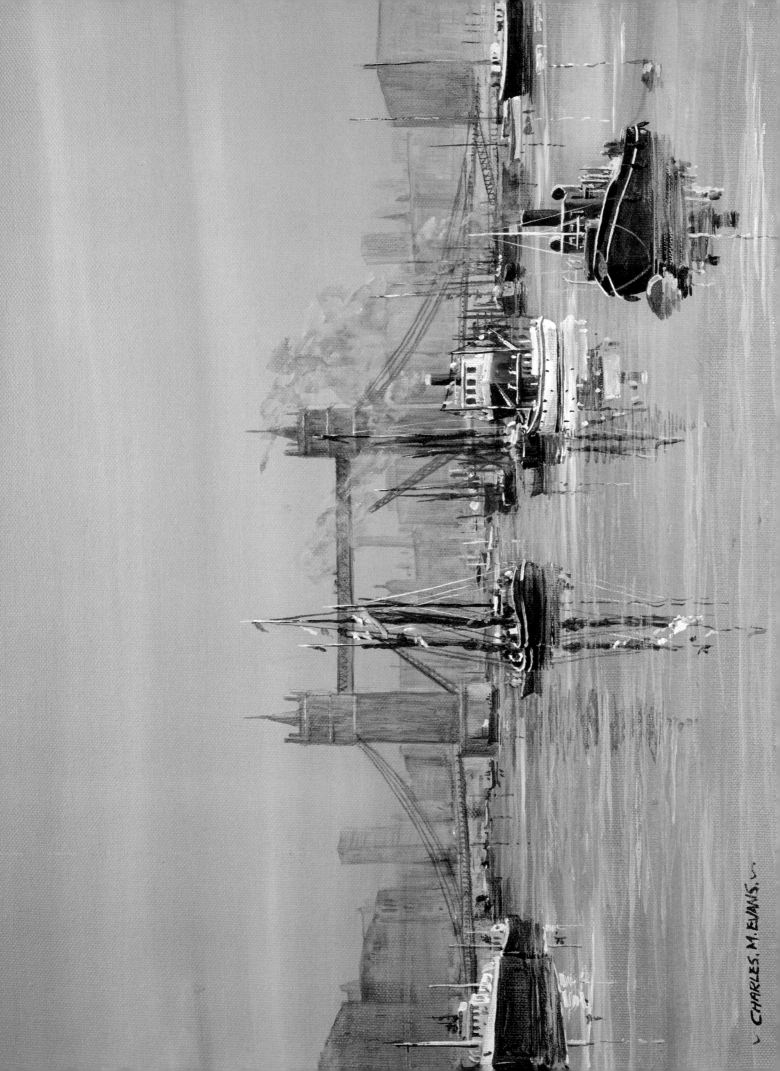

CHARLES. M. EVANS.

MYKONOS

The fishing village of Mykonos, in Greece, is both a holiday destination and a working fishing village, and I wanted the painting to reflect this rather than simply being a cute summer holiday picture; but I also wanted to add the strong light, feeling of warmth and – yet again – a different type of boat! This is another place that is full of people, but just a few in the right places will add enough of a feeling of life to a painting without cluttering it. Just a hint of an arid hillside behind the buildings will give you enough recession.

PALETTE OF COLOURS

- Prussian blue
- Titanium white
- Buff titanium
- Cadmium red
- Alizarin crimson
- Raw umber
- Naples yellow
- Hooker's green
- Burnt sienna
- Payne's gray
- Cobalt blue
- Ultramarine blue

For the hillside I used my 25mm (1in) flat brush to block in the whole thing with a mixture of raw umber with titanium white. With the same brush, I then added a few diagonal strokes of raw umber here and there, followed by a few touches of Payne's gray and burnt sienna. For the highlights on the upper right-hand sides, I put on a little stroke of buff titanium.

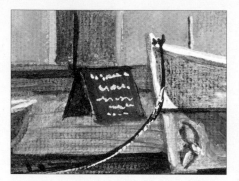

Extra little details, like this blackboard, make a big difference to a painting. For something like this you do not have to be a signwriter. Block in the whole thing with a size 8 round brush and a dark mix of ultramarine blue and burnt sienna; then, once dried, use a size 3 rigger brush and titanium white to simply put a few squiggles going across here and there.

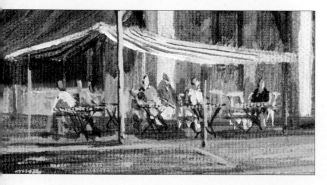

You can dress your people in any colour you wish. The flesh tone in this case was buff titanium with a hint of alizarin crimson. The tables and chairs were painted using my size 8 round brush and just a few horizontal strokes of raw umber, followed by some more strokes criss-crossed underneath to create the legs of the tables. For darkness here and there, I used a little bit of Payne's gray. The canopy was painted with titanium white and, once dried, a few stripes of alizarin crimson were added using my rigger brush.

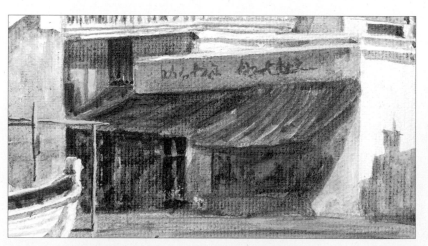

I have used strong shadow in this corner because it is out of the sunlight and there are also a lot of shadow-casting canopies there. I painted all the detail in first and then, once dried, stroked my shadow mix of Prussian blue (the same blue used in the sky), alizarin crimson and burnt sienna across the area. On top of this shop there is some writing. Like the blackboard (see above), this is just a few squiggles added using my size 3 rigger and Payne's gray.

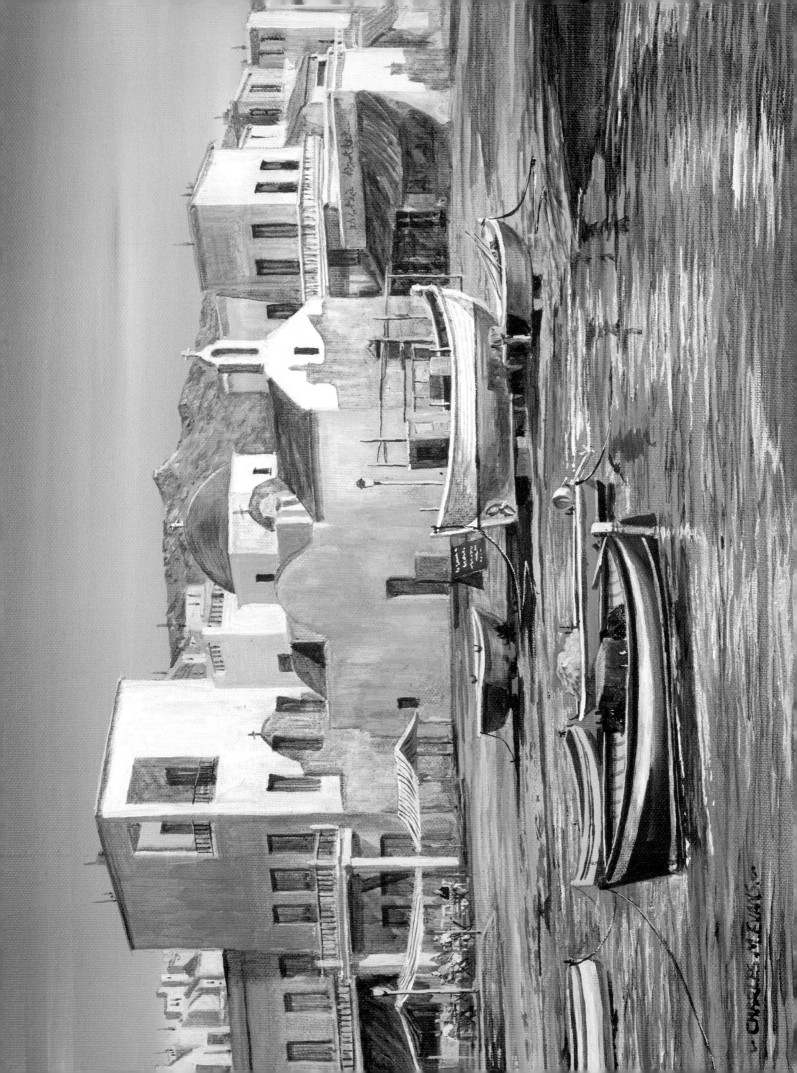

SYDNEY OPERA HOUSE

I must confess to never having been to Sydney, and this painting of the Opera House was inspired by photographs taken by a friend. When working from a photograph of a place you have never seen do not just pick up the picture and start immediately. As my mother always says, 'Give it a good coat of thinking first.'

Study the photograph and decide what you want from the painting. If necessary cut out bits you do not need. The Opera House is the important focus, not excessive clutter like the precise number of trees. Make it work for you. I aimed for progressive recession from a strong foreground, to a slightly less distinct middle ground (i.e. the buildings) to a hazy distance.

PALETTE OF COLOURS

- Cobalt blue
- Titanium white
- Raw sienna
- Raw umber
- Naples yellow
- Burnt sienna
- Hooker's green
- Alizarin crimson
- Cadmium red
- Payne's gray
- Buff titanium

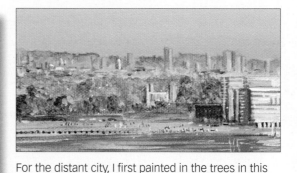

For the distant city, I first painted in the trees in this section using Hooker's green and raw sienna, a few dabs of cobalt blue here and there for darker areas and Naples yellow for highlights. Before this dried, I added vertical and horizontal strokes with pure titanium white, a raw umber and titanium white mix, and a few strokes of cobalt blue. In the same manner, I added a few touches of burnt sienna here and there. If these strokes are good and straight, they will build to look like skyscrapers in the distance.

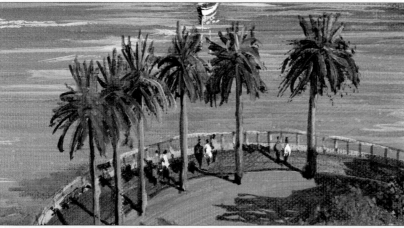

Palms are one of the easiest trees to paint in a landscape. I started off with a straight pole using my size 8 round brush and a mixture of raw umber with cobalt blue, then added a little bit of buff titanium to the right-hand side. For the foliage I drew the sharp edge of the 25mm (1in) flat brush down in the shape of the foliage with a mixture of Hooker's green, cobalt blue and a touch of burnt sienna. I then added a little bit of Payne's gray into the same mix, for stronger, darker areas in amongst the foliage. Finally, I highlighted it with a few strokes of Naples yellow here and there. The shadow colour that I used for all of these shadows was a mix of cobalt blue, alizarin crimson and burnt sienna. I wanted to get the impression that I was looking downwards onto this scene, and to this end I painted the shadows from the trees and people going diagonally upwards. Notice that some of the people have been painted in and a little bit of shadow painted through them.

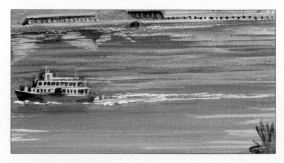

A very simple and effective way of painting the wake of a boat is using the size 8 round brush to add a few squiggles of titanium white to the dry surface of the water, painted with a mix of cobalt blue, a tiny touch of Hooker's green and a little bit of titanium white. The white touches of the wake are bigger by the boat and taper off further from it. While these were still wet I painted in a slightly darker version of the original colour of the water beneath the white here and there to add a little shadow under the wave.

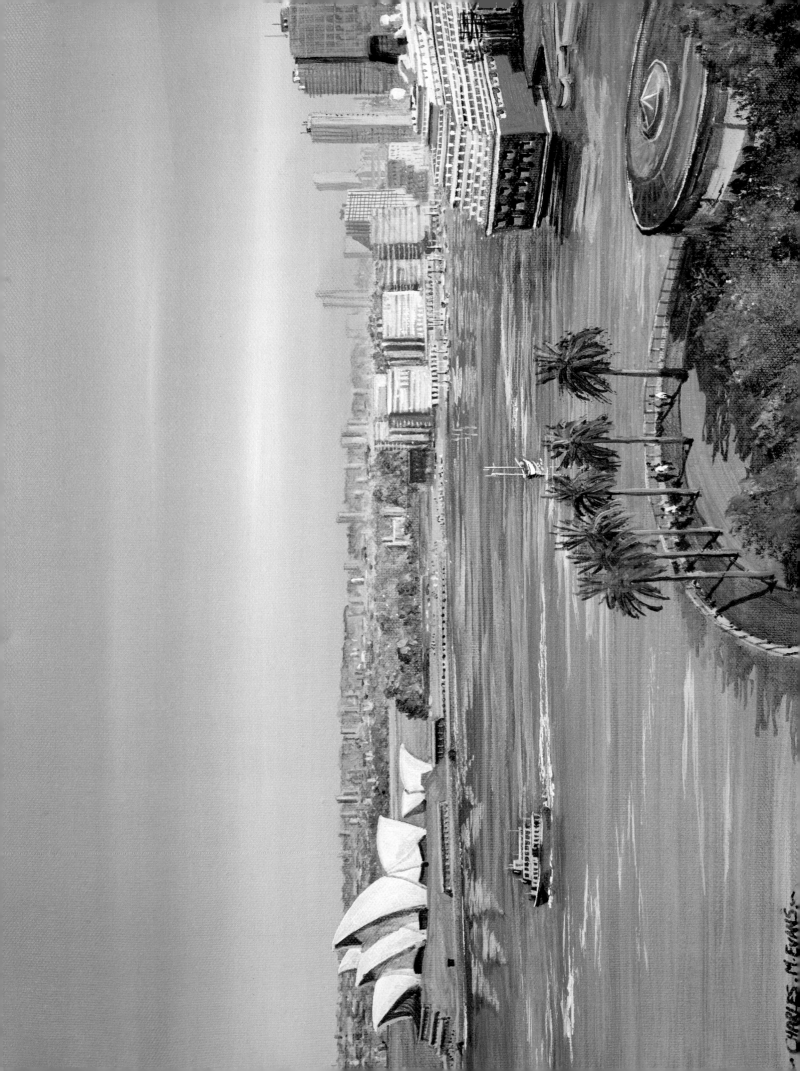

CHARLES. M EVANS

SWISS ROWING BOATS

I rarely paint mountains, but I must say that I enjoy them when I do. My whole idea for this painting was to give the mountains a slightly muted feel even though they are big and imposing in the landscape. This composition was done from quick sketches, using just an ordinary pencil, from a painting holiday a few years ago. I took my class from France to Italy and then into Switzerland over two weeks. We did this holiday in three large cars, staying in lovely hotels along the way, and so, as you can imagine, we had a fabulously varied selection of paintings. I had not taken any photographs of this place and therefore made up the colours to suit the drawings that I had. Inspiration comes in many forms.

PALETTE OF COLOURS

Ultramarine blue

Titanium white

Payne's gray

Hooker's green

Burnt sienna

Naples yellow

Raw umber

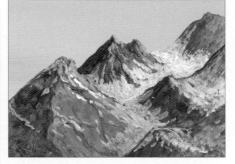

The snow on the tops of the mountains is very important. It gives a lift to the whole thing but, as always, white in shadow has a blue tint so I painted all of the snow with just titanium white to start with and then, once dried, stroked over the shaded areas with well watered-down ultramarine blue.

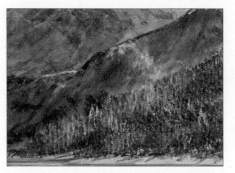

For this big clump of trees I did not paint any individual trees. Instead, I simply tapped the edge of the 25mm (1in) flat brush to the surface to give vertical shapes, using a mixture of Hooker's green and burnt sienna initially. Highlights were added with a few touches of Naples yellow, and some dark areas were added with Payne's gray.

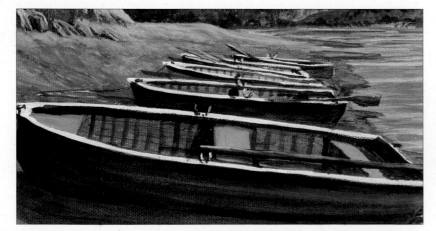

In this section it should be evident why I liked these boats so much. They are ready-made recession taking you, almost like a pathway, into the painting. Notice how each boat is shorter than the one before. For the foreground one I used ultramarine blue with a stroke of titanium white here and there to lighten and then Payne's gray mixed with the ultramarine blue for the darker areas. Note how I have painted the suggestion of detail within the boat using the same Payne's gray and blue mix. The rowlocks were painted using the same mix but then highlighted using titanium white.

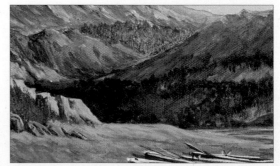

The turn in the water is very important to the distance in this painting and this is highlighted by having vastly different colour tones on the two land masses. Once I painted all the detail (like the trees) into the background mountain, I then stroked over the whole section using my 25mm (1in) flat brush with a well watered-down blue and white mix to recede it slightly. I then made the highlights on the grass in front of this very strong with the use of Naples yellow and did the same in the rocks.

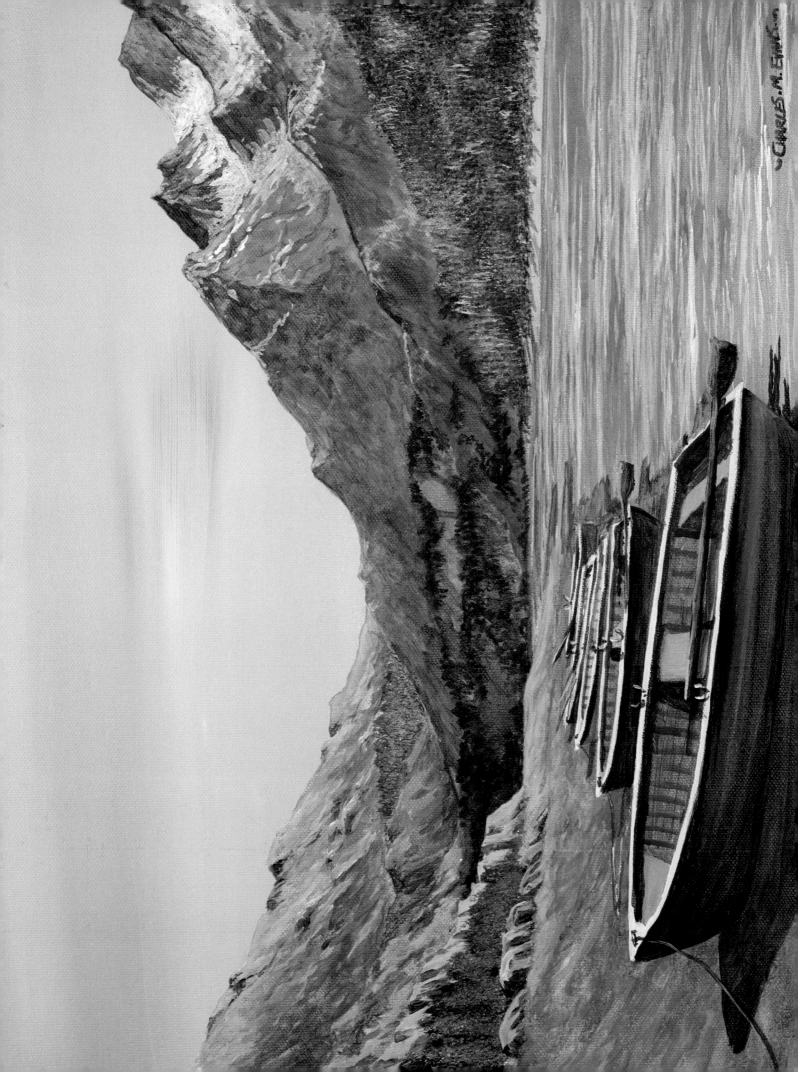

BLYTH HARBOUR

The port of Blyth is in the north east of England, not far from where I live. This painting was inspired by a black and white photograph taken by a friend of mine many, many years ago; the port looks vastly different these days. The old power station is no longer there and neither are the old freighters and steamboats.

I could not bring myself to paint purely in black and white, but I have used a very limited palette to evoke the atmosphere of a gritty working port, full of pollution and grime. In their own right, industrial scenes have a wonderfully evocative and beautiful place in artworks.

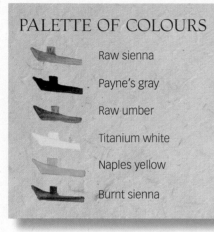

PALETTE OF COLOURS

Raw sienna

Payne's gray

Raw umber

Titanium white

Naples yellow

Burnt sienna

The sky area was covered with big, broad brushstrokes of raw sienna, raw umber and Payne's gray, then I got in there with my hands and swirled around to create the feeling of clouds mixed with muck. Once I had painted the chimneys – again with raw umber and Payne's gray – I did exactly the same as the sky for the smoke coming from the chimneys, before adding highlights of a little titanium white here and there.

This bit of sky highlights my brushstrokes or hand strokes among the wet paint. See the way I have swirled dark against light to contrast the strong Payne's gray with the lighter mix of raw umber and raw sienna. What a moody little sky this is.

It's amazing the difference a single buoy can make to a painting. This one was painted with raw umber and Payne's gray before being highlighted on the ridges by adding a tiny touch of titanium white to the original mix. The number '7' was then added good and bright with titanium white. For all of this I used my size 8 round brush.

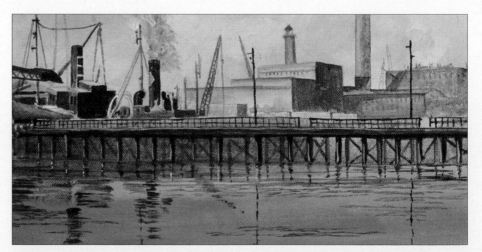

It is easy to add a little more interest and give depth to water simply by adding a few highlights. The majority of this pier or jetty was done using mixtures of raw umber followed by Payne's gray and in some places just Payne's gray. This was then reflected into the water, but just a few touches of Naples yellow here and there will add a touch of interest and light.

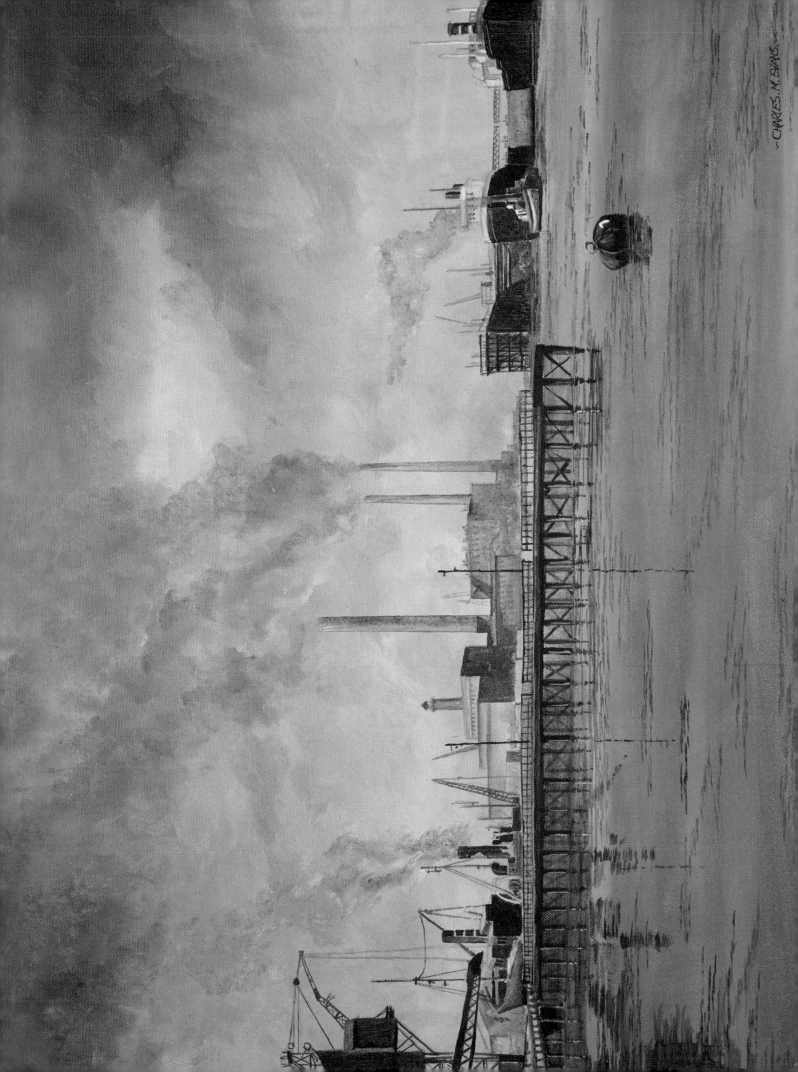

CHARLES. M. EVANS.

RACING YACHT

This was an exciting picture to paint, as the boat and sails strain against the wind and the movement of the water. It is a very close-up painting of the boat, so the detail has to be finer and more intricate than in a straightforward landscape.

With this painting, I aimed to create the impression of movement and a sense of expectation in the figures. In a composition like this, with the craft at a high angle, the water takes on as much importance as the boat and other main features.

PALETTE OF COLOURS

Cobalt blue

Ultramarine blue

Payne's gray

Hooker's green

Naples yellow

Raw umber

Buff titanium

Alizarin crimson

Raw sienna

Burnt sienna

Titanium white

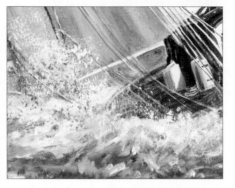

These waves are important to give the entire picture a feeling of movement and drama. I painted the parts of the boat and sail that are covered by the wave initially, so that you can see these areas through the wave in places. The technique was to simply stipple on fairly dry titanium white with my split 25mm (1in) flat brush. A few hints of this same technique were used around the back of the boat to set the whole thing in motion.

Although only small, the distant yacht is very important to give distance to the painting. No detail is needed as it is so far away. I used my size 8 round brush with cobalt blue and a touch of Payne's gray for the sail, and a quick stroke of titanium white underneath to represent the yacht.

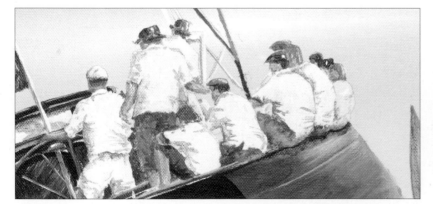

For the figures, the impression of detail is created using a little bit of shading and shadow. The whole team are in white shirts and brown trousers, painted using titanium white and raw umber respectively. The flesh tone is a mix of buff titanium with a touch of burnt sienna. Each figure was shaded using cobalt blue with a touch of Payne's gray mixed in. Notice the little bit of shading where the arm of the T-shirt meets the flesh and underneath the armpit. It is these little touches of shading that give the figures movement and more realism.

This detail illustrates how I have added a little bit of movement to all of the waves across the painting. Paint the white top and then go underneath it with a darker version of the original sea colour – in this case a mix made up of cobalt blue, Hooker's green and a touch of burnt sienna.

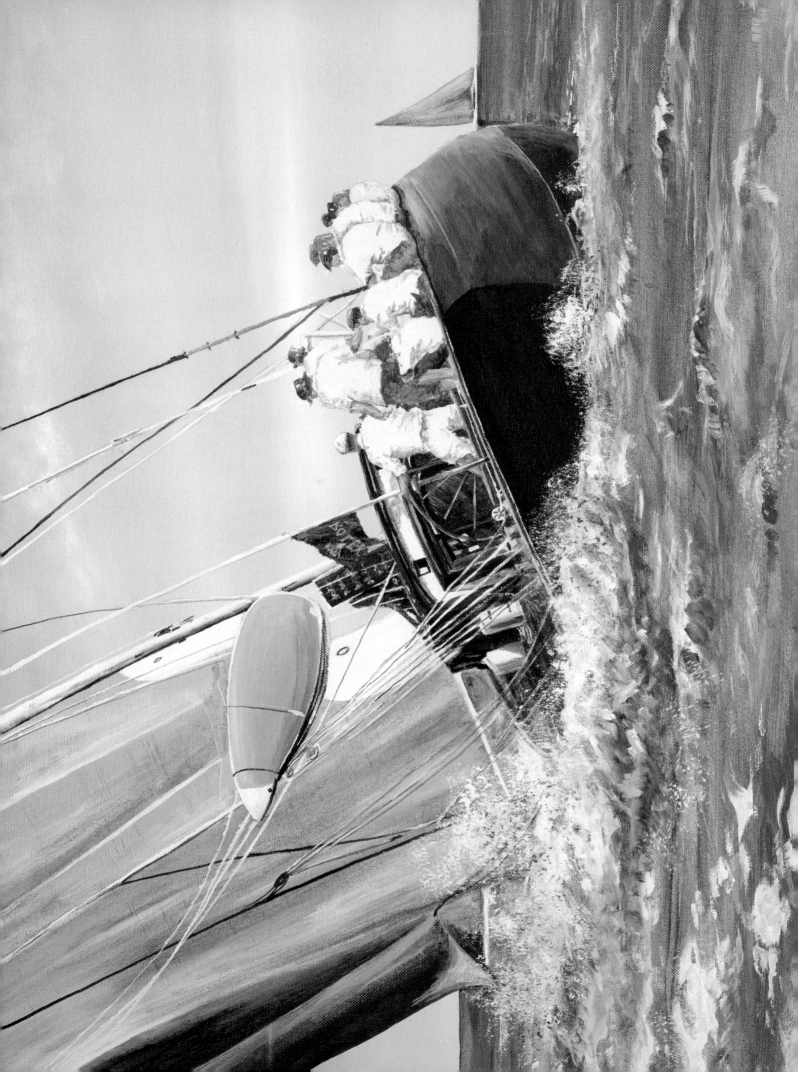

MEDITERRANEAN PORT

I particularly liked this viewpoint because it summed up perfectly a typical small port in the Mediterranean. From the little wall where I sat to do the sketch, I made sure to include just enough of the buildings that typify the colours of the Mediterranean.

The composition is not that complex in terms of the boats because I have only really painted seven or eight fully. The remainder are all bits of boats as you go further back into the distance. The trees to the right-hand side balance the painting nicely, while a lovely red sail in the middle holds the attention.

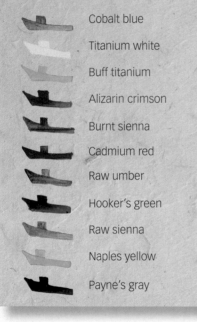

PALETTE OF COLOURS

- Cobalt blue
- Titanium white
- Buff titanium
- Alizarin crimson
- Burnt sienna
- Cadmium red
- Raw umber
- Hooker's green
- Raw sienna
- Naples yellow
- Payne's gray

A little washing line here and there gives a lovely 'lived-in' feel to a painting, especially when using bright colours like the titanium white and cadmium red used here. You do not have to do any particular shapes, such as shirts or dresses, just a blob of colour with a little bit of line – for which I used my rigger brush – coming out on either side. Also note the fact that the washing is casting a shadow onto the building.

When painting people, it is always nice to have a few in the shadows as well as standing out in the light. I painted this pair under the awning using the same tones as the other figures, and then stroked the shadow through them once dry.

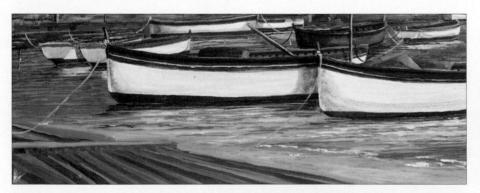

The sea came up to the little bit of sand, where it met this boarding. To be honest, I do not know what this structure was for, but it was there and it ended the bottom left-hand corner of the composition nicely. I painted it differently by mixing my raw umber and burnt sienna to create burnt umber and just did a few strips. Then, with a piece of cloth, I just wiped off the paint on the top areas so that you have light on top and dark down the sides.

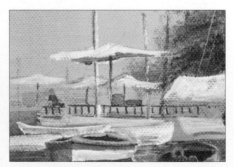

When painting umbrellas or parasols, don't just do a big blob of colour in the shape of an umbrella – you also need to show a little bit of the inside of it. This will give it more depth and a better shape. As ever, the white in shadow has a blue tint: as I have painted the outside titanium white, so the inside is cobalt blue.

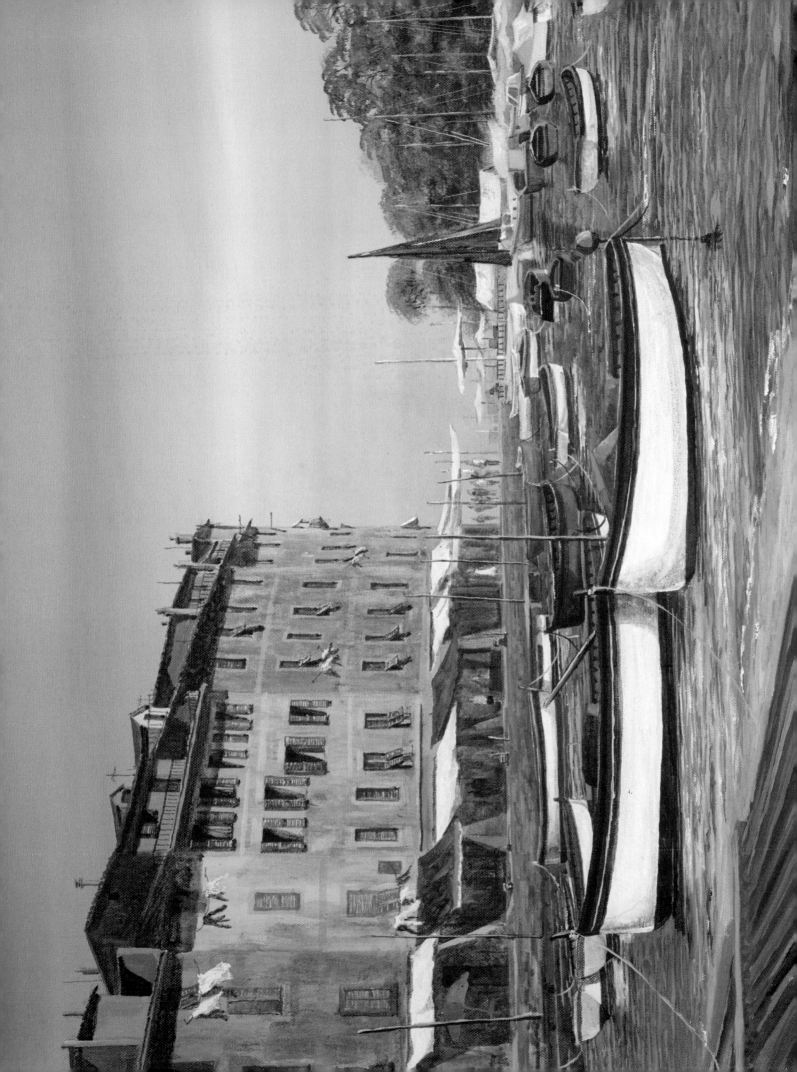

RACER

This one is quite an unusual composition for me, mainly because there is no sky, just a lot of tumultuous water. Although the base colour for the water was ultramarine blue, there's not a lot of 'just blue' showing anywhere, as I mixed it down with Hooker's green and burnt sienna and plenty of titanium white for the waves.

The main feature in the painting, the yacht, is dead central, which in some artistic quarters is not considered good practice, but I wanted to take some risks. Since this is a team racing yacht, the majority of the crew are in the same colour – in this case is a lovely bright cadmium red. I have included a fair amount of detail in the figures in order to give them plenty of presence and also to create some good, strong verticals.

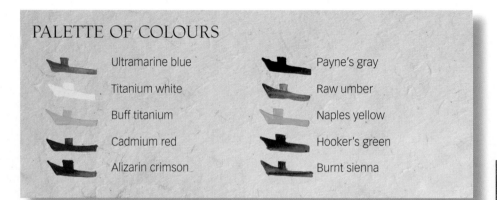

PALETTE OF COLOURS

Ultramarine blue

Titanium white

Buff titanium

Cadmium red

Alizarin crimson

Payne's gray

Raw umber

Naples yellow

Hooker's green

Burnt sienna

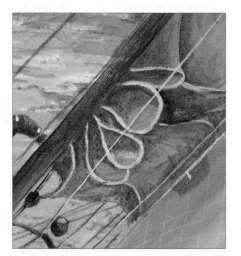

A pleasing effect is created by all these rolls where the sail has been brought down. The base colour that I used for the sail is raw umber with a touch of Payne's gray and titanium white. This mix was darkened with the addition of more Payne's gray for the insides of the folds, and more titanium white was added to the original mix for the highlights on the outer edge of the sail.

I was particularly pleased with this area, where the big wave crashes up the front of the boat and you can see the hull through the water. This was achieved by first painting the boat as a whole rather than missing bits out, and then – once completely dry – stroking the sea colour through in the direction of the shape of the wave. To finish, I stippled a little bit of titanium white on the edges here and there. For the stippling I used my 25mm (1in) flat brush technique.

As mentioned above, the original sea mix had quite a bit of green in it to achieve the right colour, but as a whole it is difficult to see the green until you focus in on one section, like this. Always have plenty of colours mixed in your sea to give it a little bit more interest – don't just go blue.

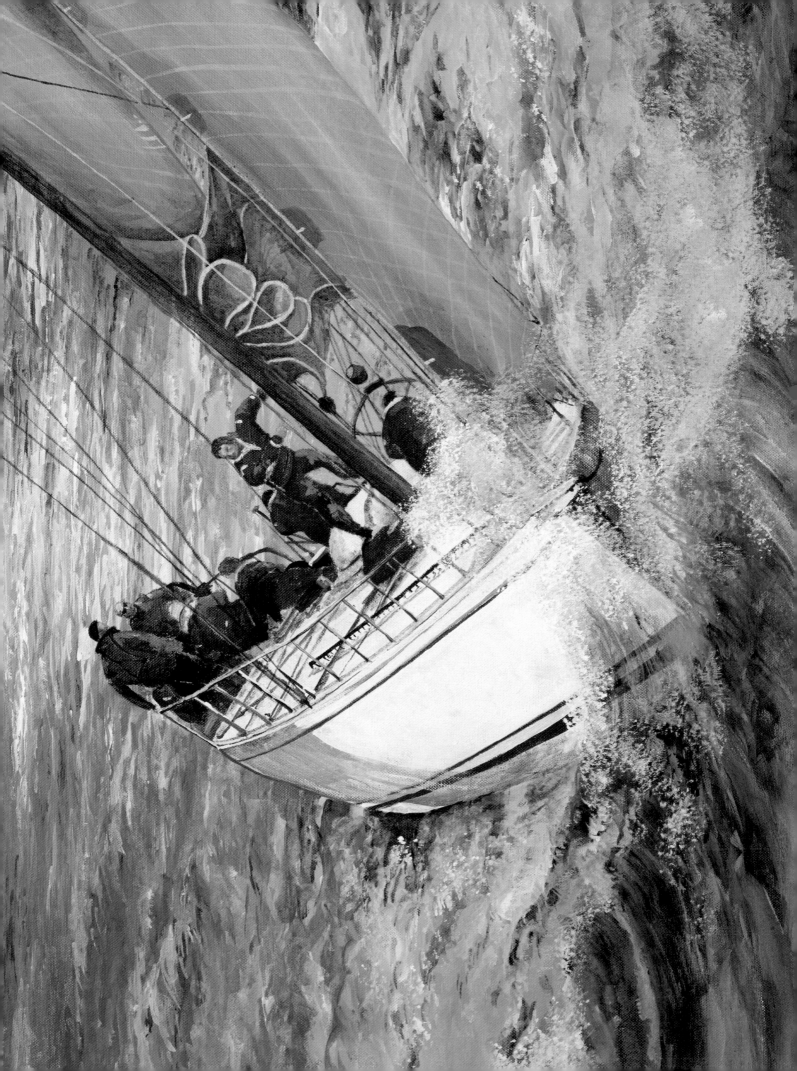

THE TALL SHIPS

I think this is a striking painting. It was composed from photographs of the Tall Ships Race when I visited Newcastle a few years ago. It is a totally made-up composition, as most of them were off the coast near Hartlepool or in dock at Newcastle when I photographed them. I simply put them out on a sea that I wanted with a sky that I wanted – and I think it worked. The sea had to be, of course, very dark to fit in with this type of sky and for this I used cobalt blue, Payne's gray and Hooker's green.

PALETTE OF COLOURS

Cobalt blue

Cadmium red

Naples yellow

Alizarin crimson

Titanium white

Payne's gray

Raw umber

Hooker's green

Ultramarine blue

Raw sienna

The colours I used for this sky were cobalt blue, Payne's gray, cadmium red and Naples yellow. To highlight the sun, I strengthened the Naples yellow in one area and then added a little touch of titanium white into the centre. I then accentuated the sun by painting clouds cutting through it using cobalt blue, Payne's gray and cadmium red. For the darker areas of cloud, add more Payne's gray to the mix.

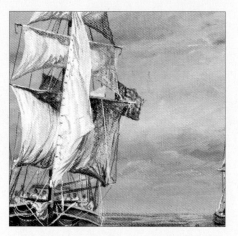

Although I have highlighted the flag in this section, the flag itself is less important than the little touch of white on the end of each strut. This brings the struts further forward than the flag, which serves to capture light on certain parts of the boat's structure.

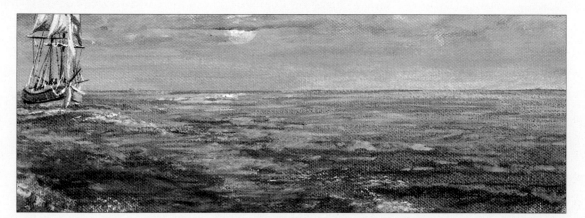

It is very important to have the strong reflection of the sun's colours in the right place, lighting up and lifting the sea in that area. Obviously, I used the same colours as I used for the sun itself, but highlighted with a little bit more white here and there. This gives the impression of the sun reflecting off the waves in the sea and adds a sense of movement to the picture.

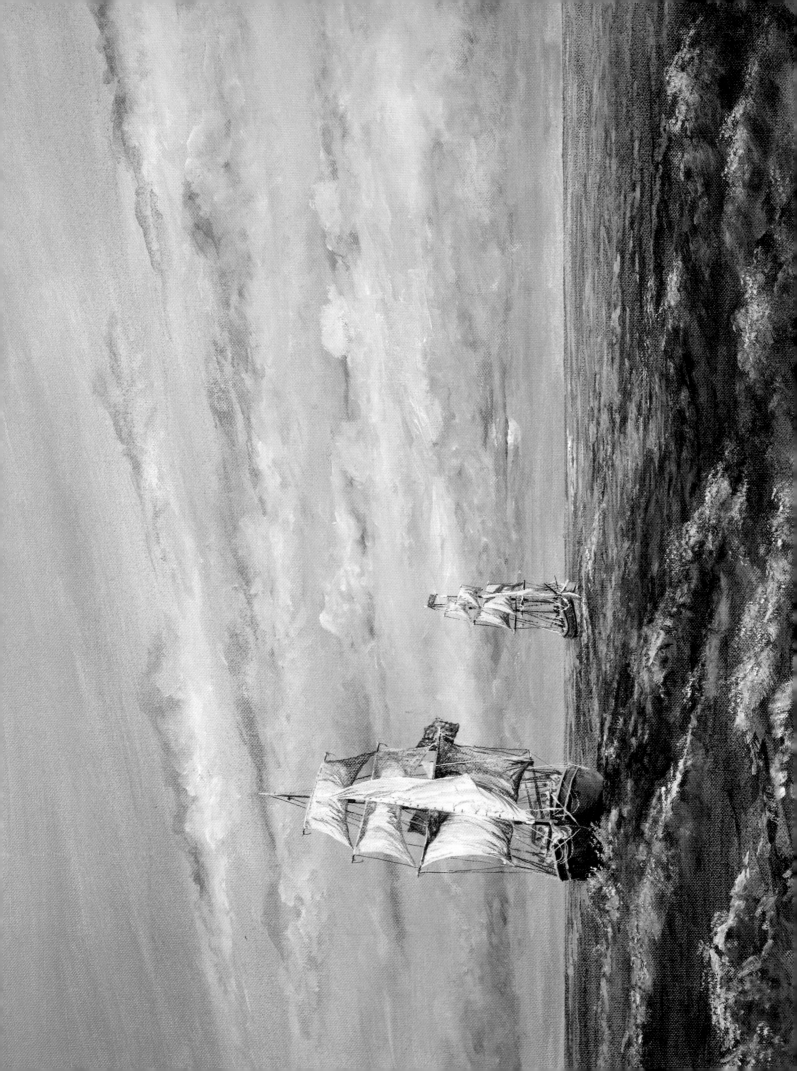

PARIS

The locations of my paintings are as important as the boats, and in this case I have chosen part of the beautiful city of Paris. I do three or four painting holidays per year in France, and at some point in every one, visit Paris to sit sketching and painting in cafés and soaking up the atmosphere. Steeped in the history of great artists, this is my favourite city.

The trees on either side form a nice frame for both the river Seine and the buildings, which lead you off into the distance. The composition is topped off with a strong sky that creates plenty of atmosphere, especially the darker areas that help to push the buildings further forward. I used a very strong blue for this sky in the form of Winsor blue, along with a little bit of alizarin crimson here and there mixed in with the blue, and titanium white for the highlights and clouds. It was a great pleasure to paint this picture from the vast body of work that I have amassed in my sketchbooks over the years I have spent in Paris.

PALETTE OF COLOURS

Winsor blue

Hooker's green

Burnt sienna

Raw sienna

Naples yellow

Payne's gray

Titanium white

Alizarin crimson

Cobalt blue

Raw umber

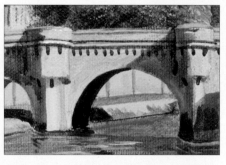

The bridge itself is painted with very light tones of raw umber mixed with titanium white to make it striking; but notice the strong contrasting shadows underneath the arches, painted with a mix of Payne's gray and Winsor blue. Note also the shadow to the right of this section, where a buttress casts a fairly strong diagonal line. Diagonals in shadow are always useful.

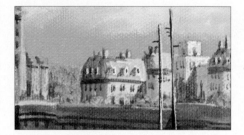

The prominent dormer windows of this distant building are just blobs of white with a little bit of a Payne's gray and blue mix for the darker side. As with the verandas they look fairly detailed in the overall scheme of things, but in actual fact they're just a thicker line of Payne's gray with a thin line of Payne's gray above and a few vertical sticks in between. This is all accentuated by the strong shadow cast by the overhang onto the building.

For the water, I first painted the green reflection with a mixture of Hooker's green and burnt sienna – the same mix I used for the trees – dragging the colour downwards. Once totally dried, I brushed through the reflections with a fairly watered-down mix of Winsor blue and Hooker's green. By putting a tiny touch of titanium white into this mix, you can create a lighter colour. A few squiggles of this will lift the water totally.

With roof lines like this, it could only be Paris. The buildings in the far distance serve to capture plenty of light at the turn in the river. I put in a little bit of Naples yellow into the lighter side of this building, which serves to accentuate the whole area.

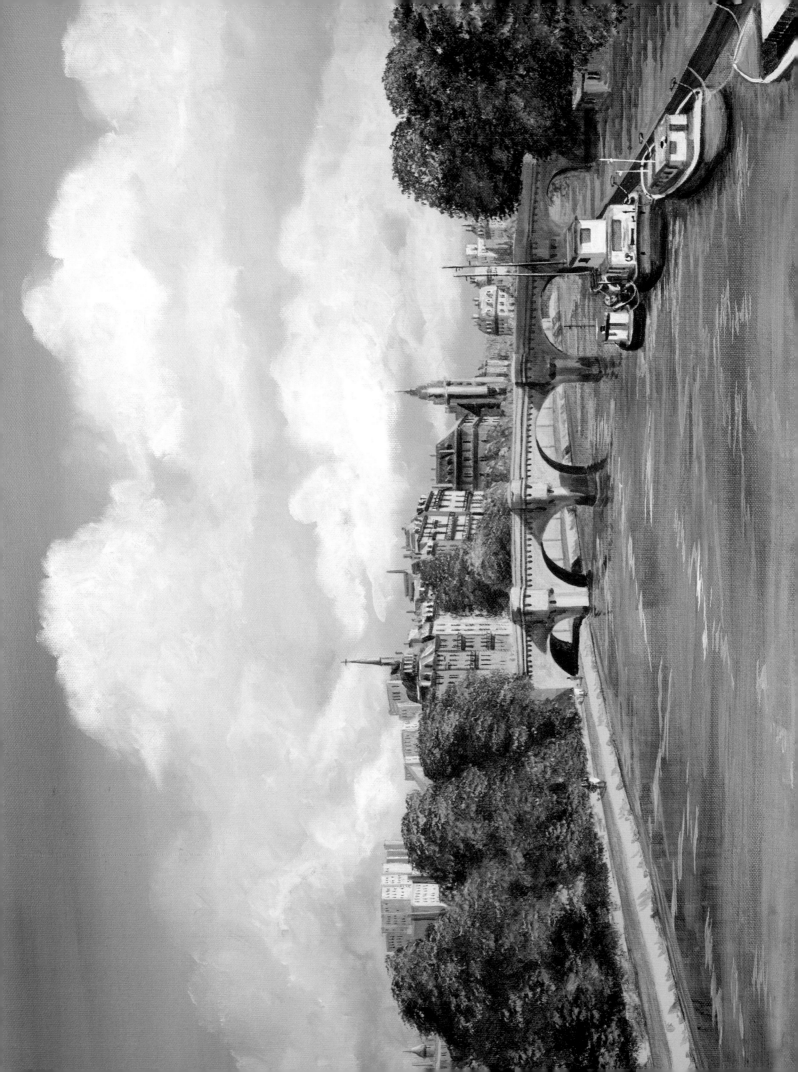

RUSSIAN ICEBREAKER

An icebreaker is an unusual subject, but I just loved the colours. The strong red of the ship stands out proudly against a cold, barren landscape and seascape. I was pleased with the coldness in the sea colour, achieved by mixing cobalt blue, Payne's gray and Hooker's green. There is a surprising amount of colour in what you might assume to be just a white landscape. In my whites I have used cobalt blue, Payne's gray and Hooker's green. A lot of colours were used in the sky including cobalt blue, raw umber, Naples yellow, Payne's gray and titanium white. All of this serves to add interest to what could otherwise be a boring, bleak landscape. This painting took me out of my comfort zone and I thoroughly enjoyed the challenge.

PALETTE OF COLOURS

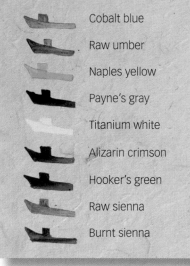

Cobalt blue

Raw umber

Naples yellow

Payne's gray

Titanium white

Alizarin crimson

Hooker's green

Raw sienna

Burnt sienna

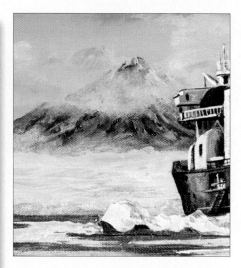

This detail highlights two important sections: first, the mountain itself, which was painted with Payne's gray and a touch of cobalt blue after I had finished the sky. Once dry, I went back to the sky to paint a couple more clouds and then worked them through into the mountain with my finger. It is nice to get a few clouds cutting through the top of the cold grey rock. The other part I want to point out here is the lighter red on the ship. I used my alizarin crimson to paint the ship and then, once dry, stroked over a little bit of dilute titanium white. This reflects a little bit of light from the ship's surroundings.

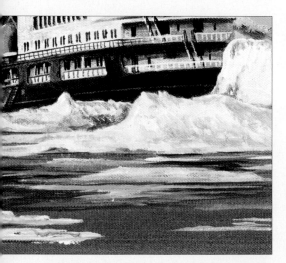

While the water was still wet I worked in a little bit of alizarin crimson to for the ship's reflection then a little bit of white on top of it here and there. This helps to add more interest to an otherwise very cold sea.

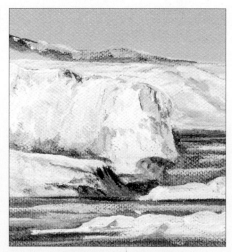

This detail demonstrates nicely what I mean by all the different colours in ice. You can see here the greens, blues and greys strengthened by a fairly strong Payne's gray and Hooker's green mix to the underside of this mini iceberg.

Putting Naples yellow into a sky may sound a little odd, but next to the darks of the Payne's gray and white mix, look how it lightens and adds interest to the sky. Topped off with a few fluffs of white cloud, it gives the whole sky a sense of movement.

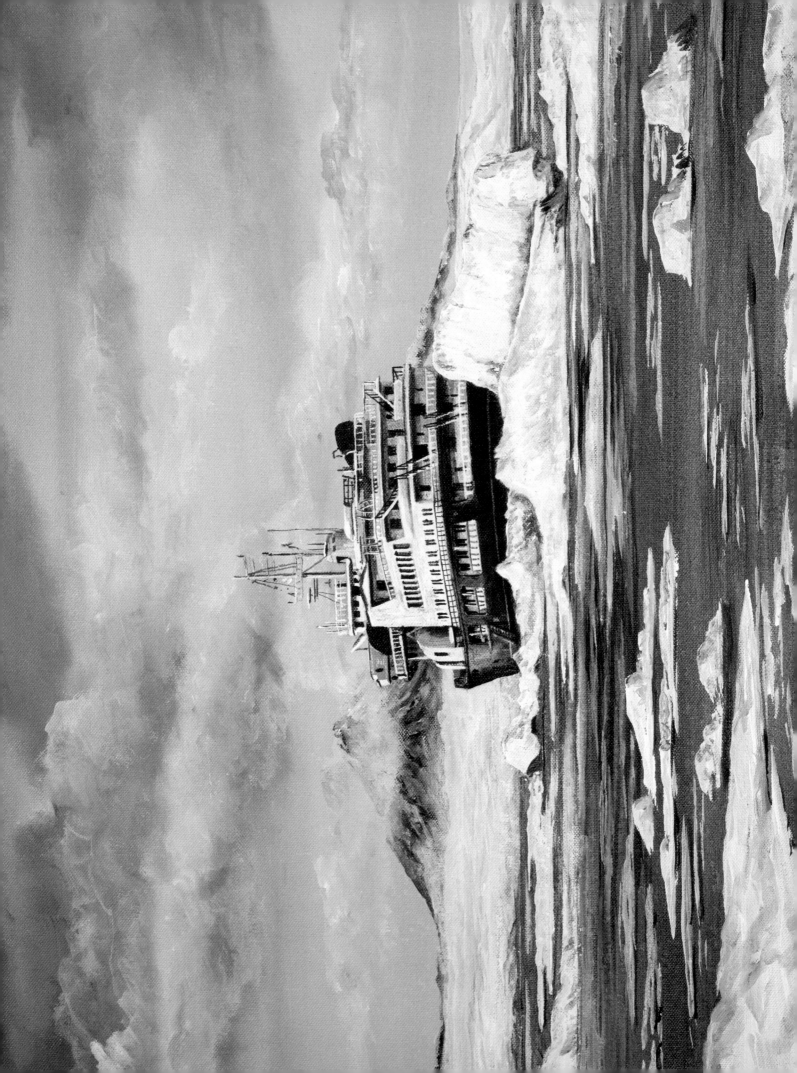

PIN MILL

One of my favourite places in England is Pin Mill, in Suffolk. The old sailing barges are an iconic feature of this area. I particularly like this area when the tide is out and the wet mudflats create a wonderful mood and atmosphere. A few muted fields in the background serve to push the boats forward in this composition.

This picture includes a particularly complex sky with lots of colours: ultramarine blue, Naples yellow, raw umber, burnt sienna, Payne's gray and titanium white. There is no pure blue in this sky; it was always mixed with Payne's gray for both the darker and the lighter areas. More Payne's gray was used in the darker areas of the sky, while Naples yellow was added to lift the top left-hand side of the sky and titanium white was used for highlighting the clouds. The sky was nothing like this on the day I did my watercolour sketches, but this stronger sky sets off the final composition nicely.

PALETTE OF COLOURS

Ultramarine blue

Raw umber

Naples yellow

Burnt sienna

Payne's gray

Titanium white

Hooker's green

Cobalt blue

Raw sienna

What look like yachts in the far distance are very simple brushstrokes of titanium white with a little bit of the same underneath as a reflection. Little touches like this serve to add interest and a feel of movement into the distance. The water itself is simply a quick broad brushstroke of a mix of ultramarine blue and Payne's gray, followed by a swathe of titanium white here and there on top.

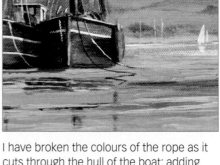

I have broken the colours of the rope as it cuts through the hull of the boat; adding more white as it goes through the darker area of the hull and more dark as it goes through the lighter areas. Notice also that the whole is casting a shadow onto the hull of the boat. Also in this detail, notice the puddles. I just painted the colours of the boats onto the sand to give the impression of reflection.

These two buoys illustrate why you must always bear recession in mind: one is further away than the other, so therefore it appears smaller. The ropes attached to them start from the foreground and squiggle off into the distance, all with the aim of taking the eye into the painting.

Within the masts and folded sail of the barge notice the titanium white highlights here and there on the rigging that I stroked through the dark clouds behind. This highlights important parts of the painting and helps to keep the viewer interested.

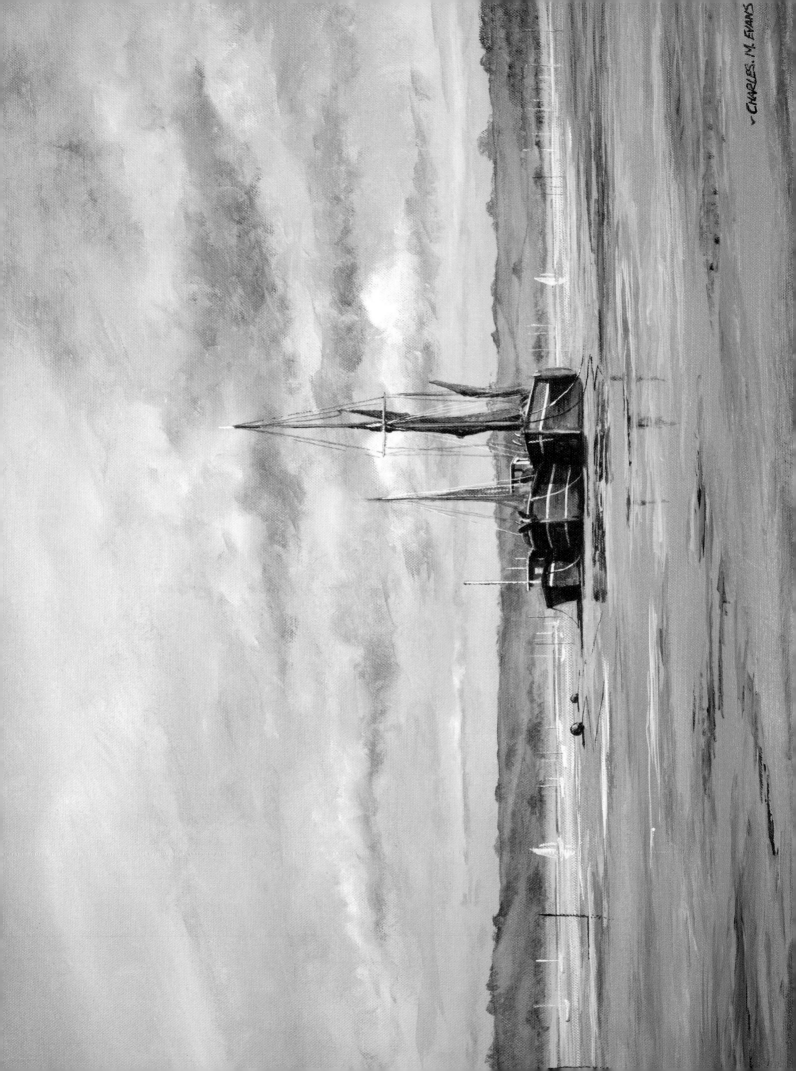

CHARLES. M. EVANS

ALNMOUTH

Alnmouth is about four miles from my house. The little inlet coming in from the foreground and going off to join the main body of water leads you in to the painting and also starts to take the eye off to the village of Alnmouth in the distance. I didn't have to accentuate this sky in any way, as this is the kind of thing we are used to seeing up here in this beautifully rural county of seas and hills. Anyone familiar with the area would know straight away that this was Alnmouth because of the multicoloured buildings to the left-hand side of the village. I always find that this kind of scene is at its best once the mudflats are revealed.

PALETTE OF COLOURS

Cobalt blue

Naples yellow

Payne's gray

Titanium white

Hooker's green

Burnt sienna

Alizarin crimson

Raw umber

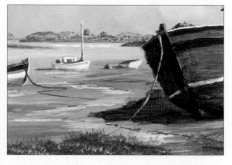

This little bit of rope leads the eye to the boat as the foreground grass finishes. Using my size 3 rigger brush, I ran through the dark landscape with plenty of white and through the lighter areas with plenty of dark. The strong shadow underneath the boat was painted using cobalt blue – the blue of my sky – mixed with alizarin crimson and burnt sienna. Also, notice how I flicked some grasses up in front of the water to make them stand forward from the water.

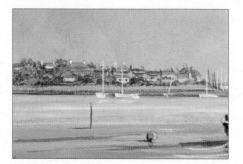

A little bit of interest in the far distance can easily be created by a few verticals. These could be masts, posts or whatever else you please. Paint them light against dark and suggest the distant boats with hints of titanium white.

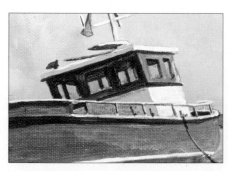

To make the wheelhouse of the boat more realistic, I have allowed the viewer to look inside it by painting Payne's gray in the shape of the rear window frames and underside of the roof through the squares of the windows on the front. Once this had dried, the windows were glazed with a fairly watered-down mix of cobalt blue and titanium white.

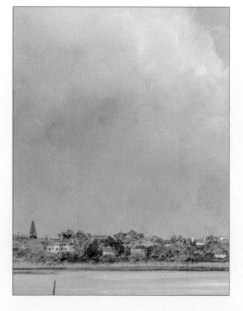

The lightest part of the village is underneath the darkest parts of clouds; a technique known as counterbalance. The dark sky behind the lighter part of the village helps to accentuate and push the village out. The effect is heightened by having some of the lightest parts of the clouds above the darkest part. The village was painted with a few simple strokes of burnt sienna mixed with white for the roofs, a little bit of raw umber mixed with white here and there for the walls and the odd touch of white to top off the chimneys, but by no means was I painting detailed buildings.

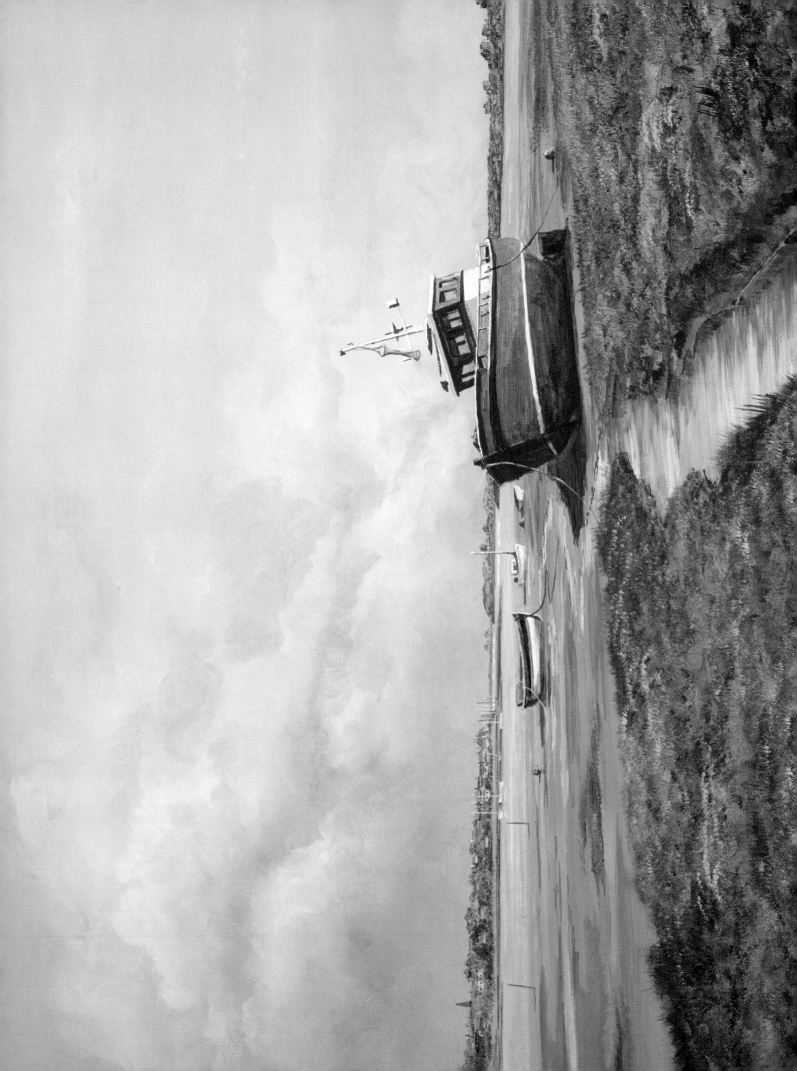

ALDBURGH

Aldburgh, in Suffolk, UK, can be a bit of a blustery place sometimes, and I have tried to sum that up with the sky in this painting. It was based on a mix of cobalt blue with Payne's gray and alizarin crimson. It is a scene that has been photographed many times, mainly because of the fact that they pull the boats up onto the beach.

This seaside town is quite a busy little place, but there is no need to paint hundreds of people – just a few will do. I was actually staying in the hotel in the painting – the big building at the end of the row – while doing a workshop in the area. I had a couple of hours to kill at the end of the day, and so made a quick few sketches of the scene.

PALETTE OF COLOURS

Cobalt blue

Naples yellow

Alizarin crimson

Payne's gray

Titanium white

Raw sienna

Raw umber

Buff titanium

Ultramarine blue

Hooker's green

Burnt sienna

To represent yachts in the distance on the horizon line, I simply put a few white strokes against the darker part of the sky. Notice that I have not used vertical brushstrokes. Instead, I have put them at an angle, in order to help create the impression of a blustery day.

Tractors are used on the beach in Aldburgh to pull the boats up and push them back into the sea, and there were quite a few tractor tyre marks on the beach on this particular day. None of the marks were in the place I have put them; instead, I have used them to help the eye into the painting, acting like a path.

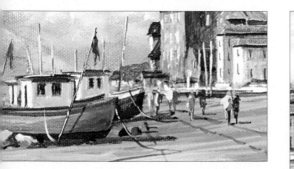

In the section to which the tractor marks lead, I have put some good strong shadows to tie both the people and the boats down to the ground.

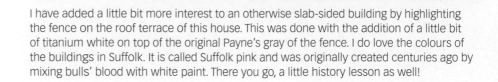

I have added a little bit more interest to an otherwise slab-sided building by highlighting the fence on the roof terrace of this house. This was done with the addition of a little bit of titanium white on top of the original Payne's gray of the fence. I do love the colours of the buildings in Suffolk. It is called Suffolk pink and was originally created centuries ago by mixing bulls' blood with white paint. There you go, a little history lesson as well!

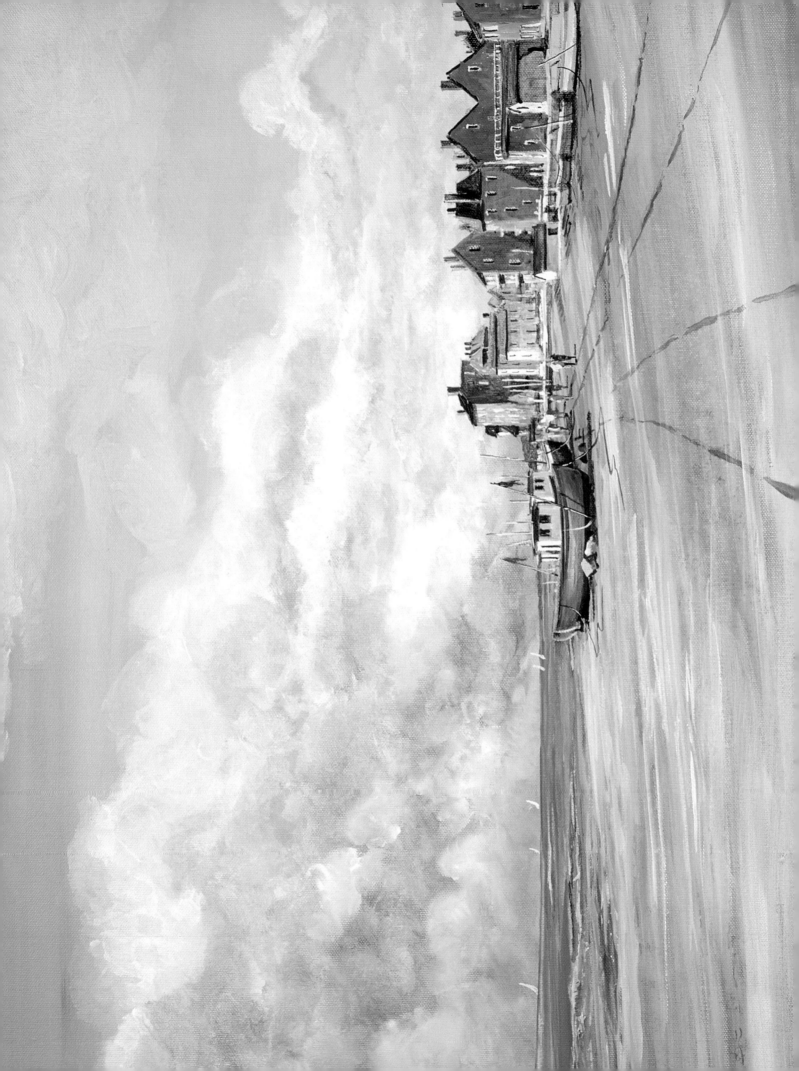

MAOL CASTLE

I love Scotland, especially the more barren areas. All of these areas have a beautiful emptiness to them. They are the kind of places where you can lose yourself in your thoughts and your paintings. The sky in this was a particularly strong and vibrant one, which really adds to the atmosphere. It was mixed from Winsor blue, a little bit of Hooker's green and quite a bit of both titanium white and Payne's gray.

I do a lot of workshops and demonstrations for art societies all over Scotland; and was once stranded on the Isle of Lewis for five days because I did not realise that everything – including the ferry – stops on Sundays. A night without red wine, oh my word, I do suffer for my art.

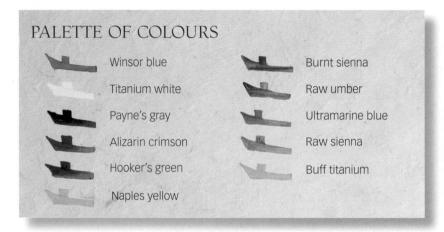

PALETTE OF COLOURS

- Winsor blue
- Titanium white
- Payne's gray
- Alizarin crimson
- Hooker's green
- Naples yellow
- Burnt sienna
- Raw umber
- Ultramarine blue
- Raw sienna
- Buff titanium

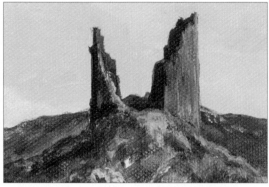

The ruin of the castle was painted using a mix of raw umber and burnt sienna. What makes it more imposing is the fact that you can see inside the ruins as well. This effect was achieved by using Payne's gray for one side and a lighter version of my raw umber mix for the other, and then accentuating the broken bit of wall on the left-hand side with a little bit of Naples yellow. This is the light that you can see.

I do not know for certain what this little white building was, though I would guess it is some kind of a watchtower. All I do know is that with a stroke of titanium white, a bit of Winsor blue down one side, and burnt sienna on top as a roof, I created an instant bit of interest and focus to that side of the lake. Notice that I have also reflected it in my water underneath.

I want to draw your attention to the way I have made the mountains work for me in this painting. Very dark mountains are set at the back, which helps to push the lighter mountains in front further forward. The dark colour was created with a mix of raw umber, burnt sienna and Payne's gray; and a few touches of white were stroked into the top areas while still wet. The lighter mountains were painted using raw umber, titanium white and a few touches of burnt sienna and Naples yellow here and there. I painted the mountains once the sky had been painted in fully, then returned to the sky for further detailing. Using the tip of my finger I worked a little bit of titanium white into some of the existing clouds, and pulled some of it down into the mountaintops.

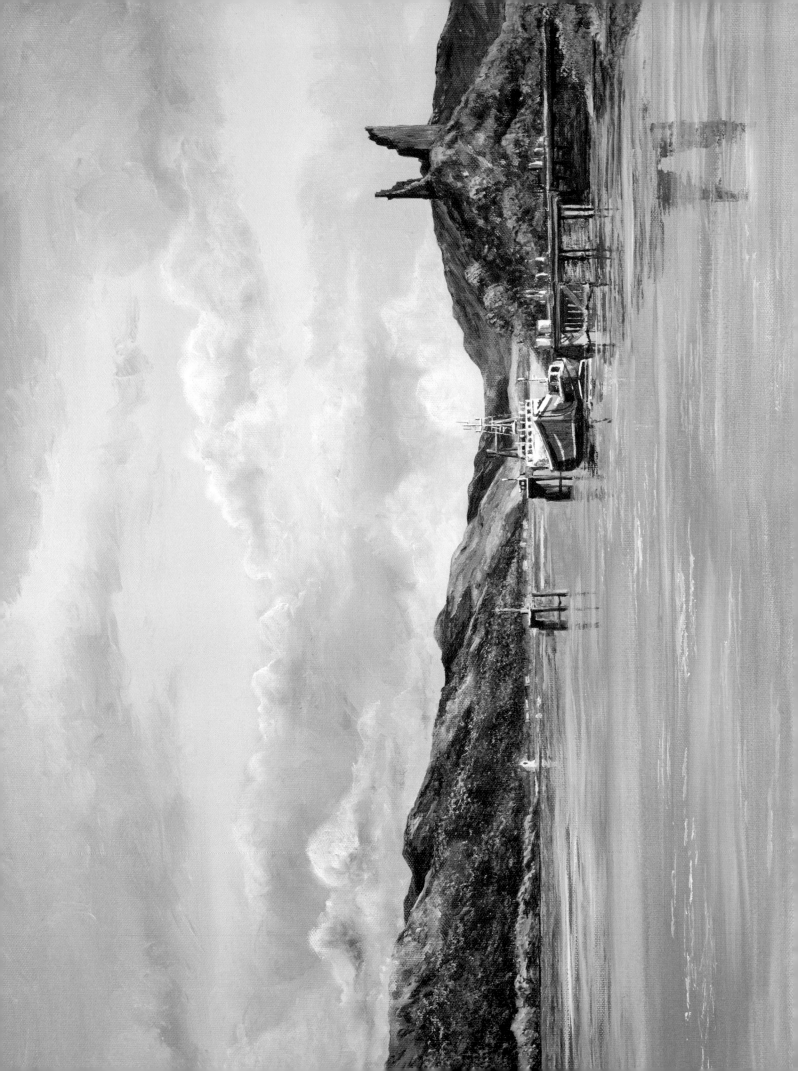

THAILAND JUNKS

This painting – hopefully not a load of junk – is of a Thai junk, a type of boat that I have never seen in person but find interesting, especially against the mountain formations common in these areas. What first attracted me to this kind of mountain was seeing them many years ago in the James Bond film, *The Man with the Golden Gun*. It is amazing the things that can inspire you.

I was pleased with the depth of colour that I got into this painting, particularly with the reflection of the sky between the mountains. Taking yourself out of your comfort zone by painting different kinds of grasses or trees on these unfamiliar mountains is an enjoyable challenge.

PALETTE OF COLOURS

Cobalt blue

Titanium white

Alizarin crimson

Hooker's green

Burnt sienna

Naples yellow

Raw umber

Raw sienna

Payne's gray

Cadmium red

Buff titanium

The impression of a little man in a rowing boat was created with a very simple stroke of raw umber mixed with Payne's gray to create the rough shape of the boat with a touch of titanium white, shaded with cobalt blue, for the man. This gives the idea of scale to the big boat.

Once I had painted the greenery in the mountain, I highlighted it quite strongly with Naples yellow, stippling it on using my split, flat brush.

A challenging part of these mountains is getting the foliage to look like as though it is on top of the rock rather than blending into it. To get this effect, I first painted the mountains with mixtures of raw umber and cobalt blue, followed by raw umber mixed with titanium white. With the tip of my size 8 round brush, I highlighted a few crags and cracks with Payne's gray and then again, here and there, using a little bit of titanium white. Once all of this had dried, I stippled on a mixture of Hooker's green and burnt sienna with my split flat brush. I allowed this to dry then stippled Naples yellow on top. Finally, I used a shadow mix of cobalt blue, alizarin crimson and burnt sienna to paint shadows cast from the growth onto the rock.

The sails of these big junks are really quite something. I used alizarin crimson mixed with a little bit of raw sienna for the main section and highlighted the ribs with the addition of more raw sienna into the mix. This was followed by a little bit of Payne's gray into the original mix underneath the lighter sections. This all helps to make a crinkly, ribbed sail.

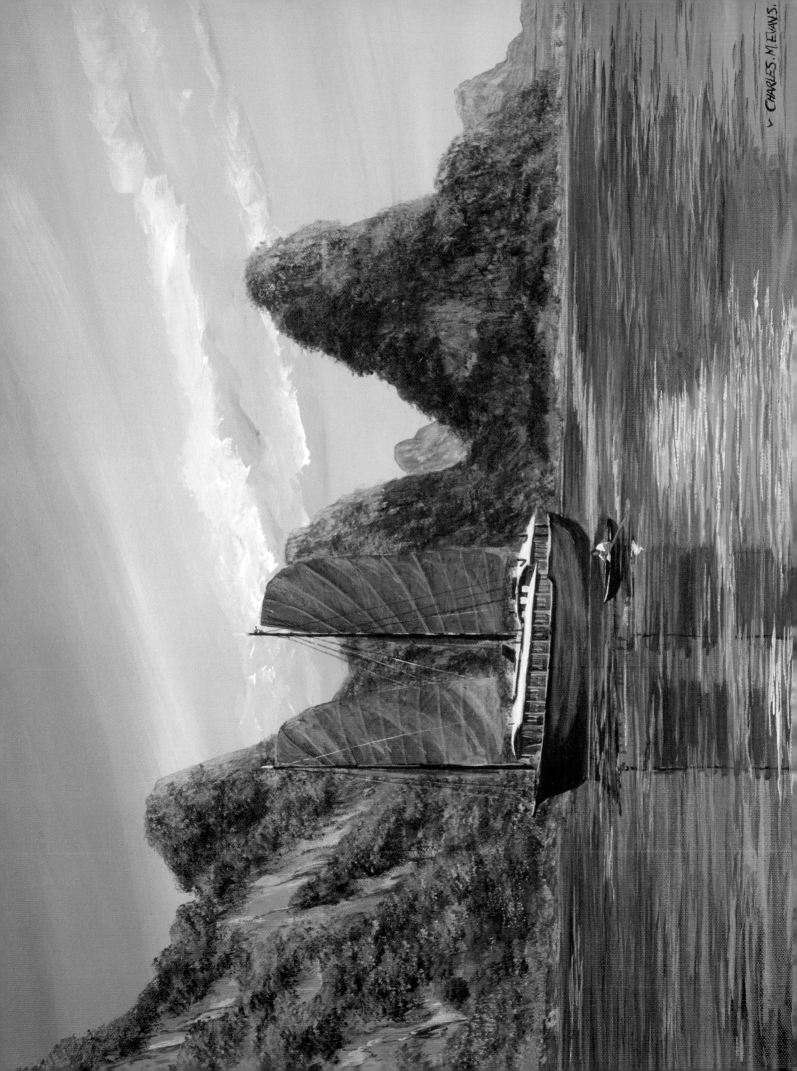

MISSISSIPPI RIVERBOATS

You can not really have a big book about boats without featuring some iconic riverboats from Mississippi, in the USA. These riverboats come in all shapes and sizes and have been around for centuries, both as working and as pleasure boats. Even I, at my ripe old age, was not around to do sketches or quick painting when all of this was happening, so the source material for this painting was taken from old black and white photographs. I wanted to make this painting look old, and therefore I have used very few colours to give a kind of sepia effect. The entire composition is as much about the hard work that went on around these things as about the boats themselves.

PALETTE OF COLOURS

Ultramarine blue

Titanium white

Raw umber

Payne's gray

Burnt sienna

Raw sienna

Buff titanium

Naples yellow

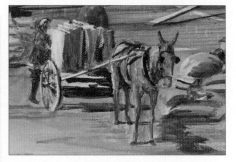

The poor old donkey pulling the overladen cart typifies the hard work that went on in those days, and this kind of detail really adds interest to the whole composition. As with most of the picture, the donkey was painted using raw umber, both pure and in mixes with Payne's gray and titanium white. These same colours were carried through to the cart, highlighted with a lot more titanium white into the raw umber.

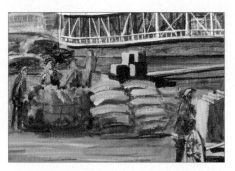

In the general workings of the quayside, it looks like there are lots of sacks piled up. This detail shows that they are just curved strokes of raw umber, highlighted with a bit of titanium white on the top and darkened with Payne's gray on the bottom; no other details are needed.

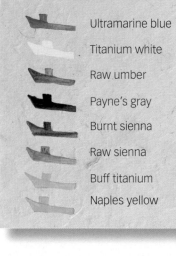

As mentioned, I have used very few colours in this painting. The American flag here is not painted with red, white and blue; but instead Payne's gray for the blue section, raw umber mixed with burnt sienna for the red stripes and titanium white for the white. This shows how easily the eye can be fooled.

Raw umber has been used for the lighter sections of the trees in the background. Payne's gray was added to raw umber for darker sections and used neat for the darkest touches. The distant buildings were painted with the same colours, along with a highlight mix of raw umber and titanium white for the roofs.

It may look like we have lots of figures on these boats, but when you pay close attention the figures standing in the shadows are just touches of Payne's gray.

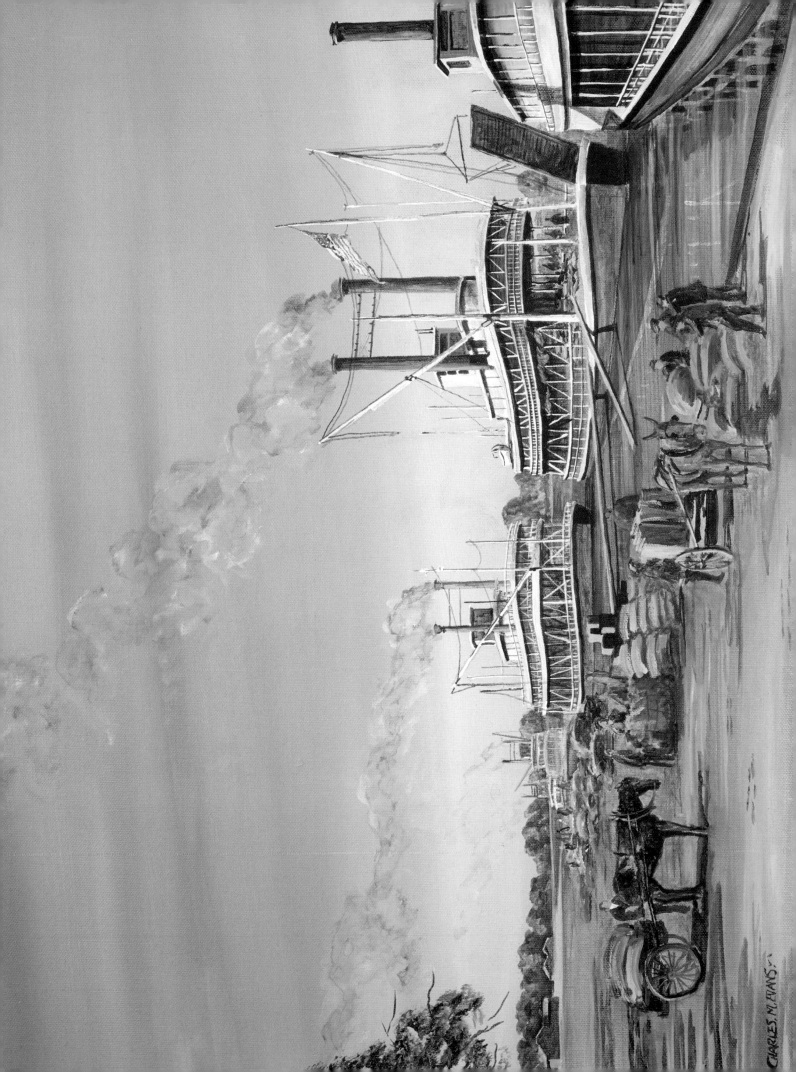

CHARLES. M. EVANS

VENICE

I have been to Venice many times on painting holidays with groups of people. The minute I see the buildings as we make our way in on the water taxi, my fingers are twitching and itching, waiting to get some paper out. This place is just so steeped in history and has been painted by many of my artistic heroes from centuries past. Even on an overcast day, such as this, the light in Venice is just incomparable and the colours in the buildings reflect their age and character. How can you fail to be inspired with scenes like this around every corner?

Apart from a few of the iconic gondolas, not many boats are included in this picture; but as everyone knows, they are important to Venice. For this reason, I was sure to include the striking colours of the gondolas and – just as importantly – the gondoliers.

PALETTE OF COLOURS

Cobalt blue

Titanium white

Alizarin crimson

Raw umber

Raw sienna

Payne's gray

Cadmium red

Buff titanium

Hooker's green

Naples yellow

Burnt sienna

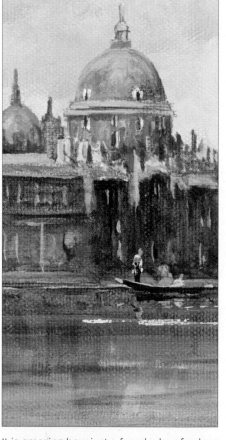

A mix of Payne's gray and burnt sienna created a beautiful strong black for the gondola. For the figure, a couple of sticks of the same black mix were used for his legs along with a touch of titanium white above them. Once the white had dried, I painted a few red stripes using my rigger brush. The same brush was used to highlight his pole with a little bit of Naples yellow.

It is amazing how just a few daubs of colour around the dome to add a little detail will make the surrounding area look like buildings without having to paint lots of specific detail. These touches are just raw umber mixed with Payne's gray. I dragged my brush downwards, vertically, and topped them off with burnt sienna mixed with titanium white. Notice how just a little bit of a daub of Naples yellow in the water, just off-centre of the painting, gives added light and interest and serves as a reflection for the buildings above.

Have plenty of verticals going on in a painting like this, it lifts all the buildings. Chimney pots, spires, poles, anything. Search for verticals.

A few well-placed blocks of purple – a mix of cobalt blue and a little alizarin crimson – will create distance by giving the impression of distant buildings. Look how they serve to push forward the mix of titanium white and Naples yellow, which creates the building in front.

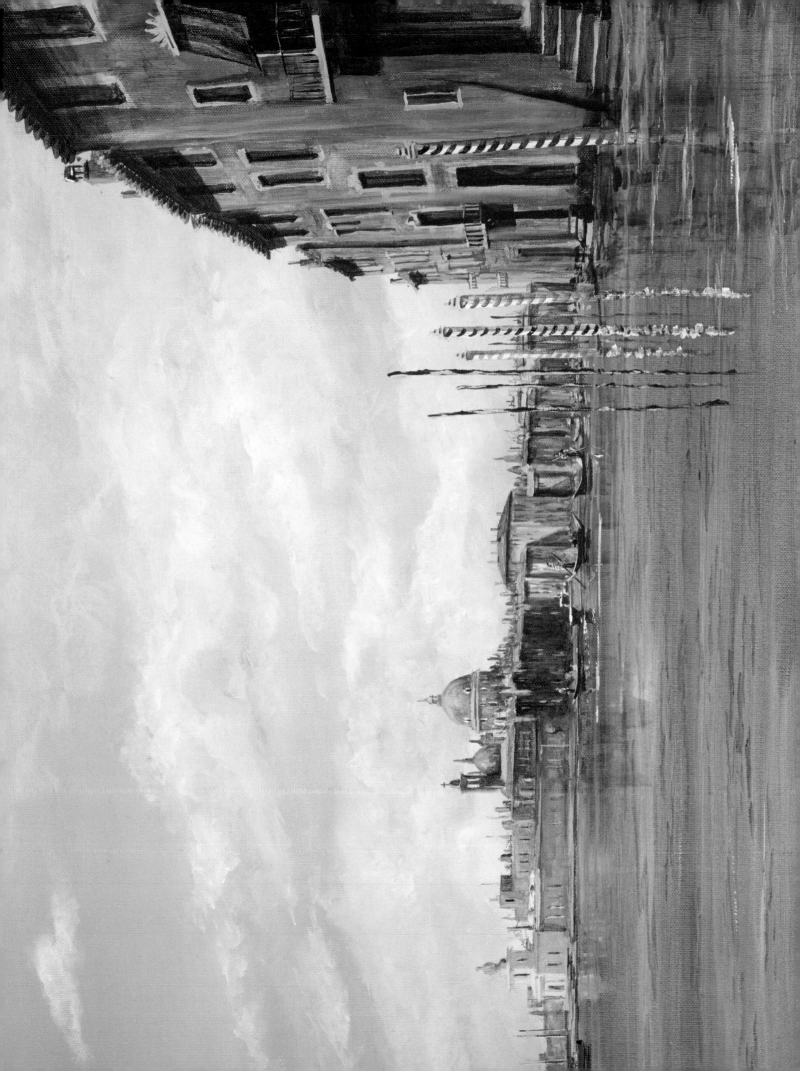

TOBERMORY

I picked this part of the harbour at Tobermory, on the Isle of Mull in Scotland, because this is where the lovely old-fashioned fishing boats are moored. It leads out to the gorgeous headland behind of wooded fields and hillside. As I was doing my watercolour sketch there, I liked the way the light hit part of the hills in the distance, and so aimed to capture this effect on the canvas.

When I first visited the island I was staying at my friend Callum's house and expressed an interest in driving to Tobermory to have a look. I was amazed when he said it was a two-hour drive – I had no idea that the island was that big! The trip was well worth it: as well as getting inspiration for a lovely painting out of it, I also got to see my first ever golden eagles, as two of them soared above me on the thermals. You could see their wings outstretched, their feathers like fingers at the ends. What a beautiful sight and what a beautiful day.

PALETTE OF COLOURS

- Prussian blue
- Titanium white
- Naples yellow
- Payne's gray
- Hooker's green
- Burnt sienna
- Raw sienna
- Alizarin crimson
- Cadmium red
- Cobalt blue
- Ultramarine blue
- Raw umber

I used Prussian blue to create a strong yet bright sky, helped by the use of titanium white to create the tops of the clouds, which I did by rolling my finger into the paint. When focusing in on one you can see how effective this can be with the strength of the white showing good and bright against the dark of the Prussian blue.

I have created interest on top of the harbour wall with some deliberate clutter. Just a few strokes here and there of Prussian blue highlighted with white, a little bit of raw umber for a few sacks and a few verticals. This stuff can be fairly meaningless to be honest, but it all helps to make the painting a little bit busier in order to suggest a working scene.

This little grouping creates interest in the middle distance. The white yacht is simply titanium white with a little bit of blue. As important as the boat itself is the broken white reflection. Because the blue boat is a man-made object, it can be a different blue to the sky and water, so I used ultramarine blue for this. Notice the couple of little red buoys also reflecting in the water. A spot of red in a painting is always a useful way of making the eye go to where you want it.

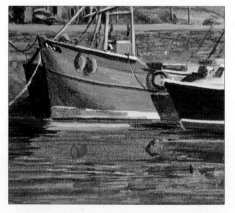

I want movement in the water, so although the reflections are strong, they are not a mirror image. Good strong colours were used for these broken reflections. The lovely orange is alizarin crimson mixed with raw sienna and highlighted with a little bit of titanium white. The original colour for the water is Prussian blue with quite a bit of Hooker's green mixed in and a touch of burnt sienna.

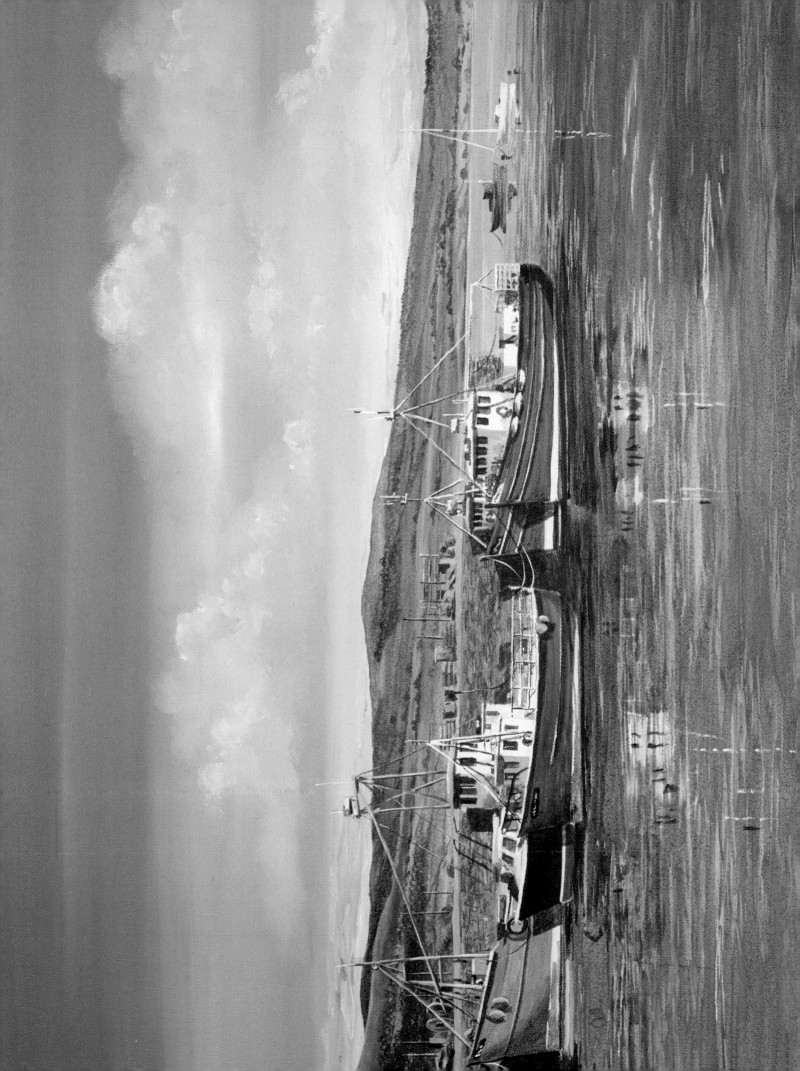

INDEX

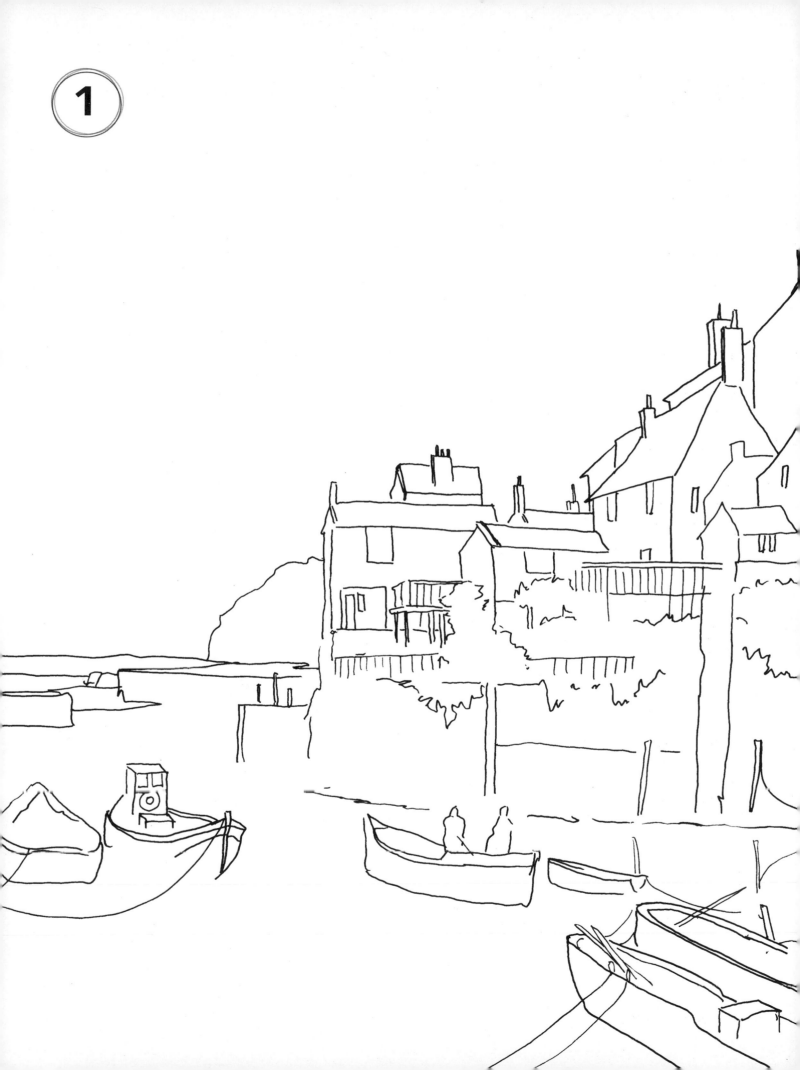

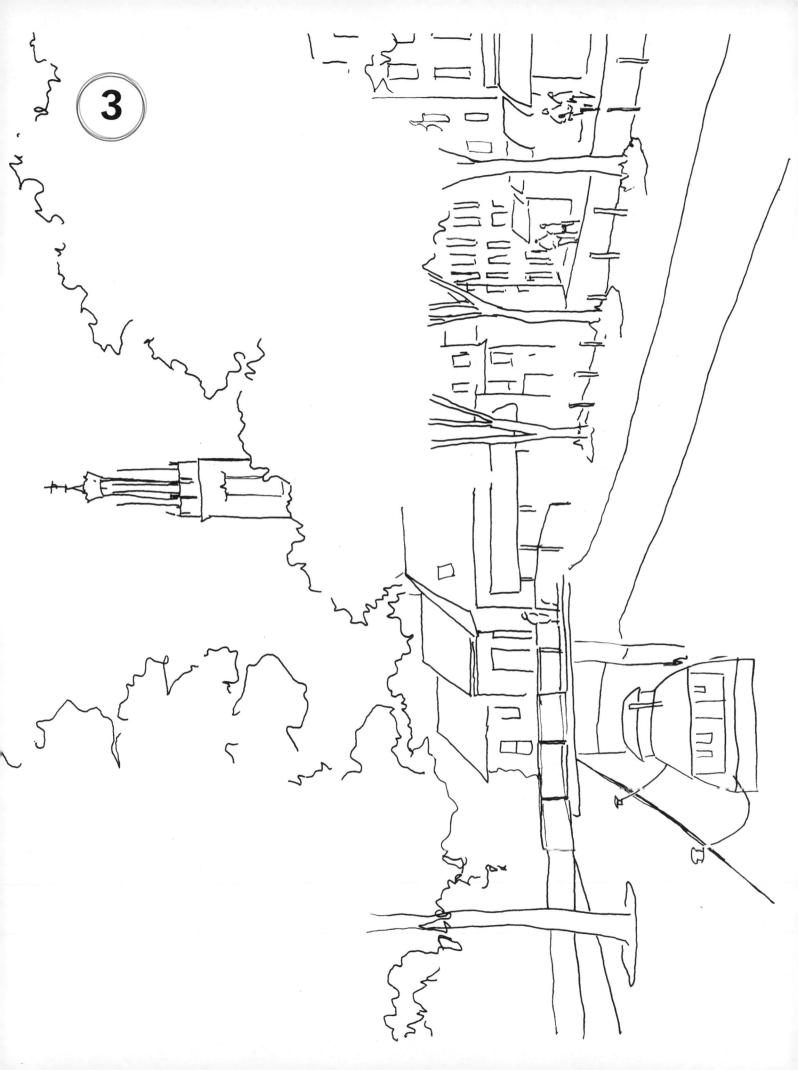

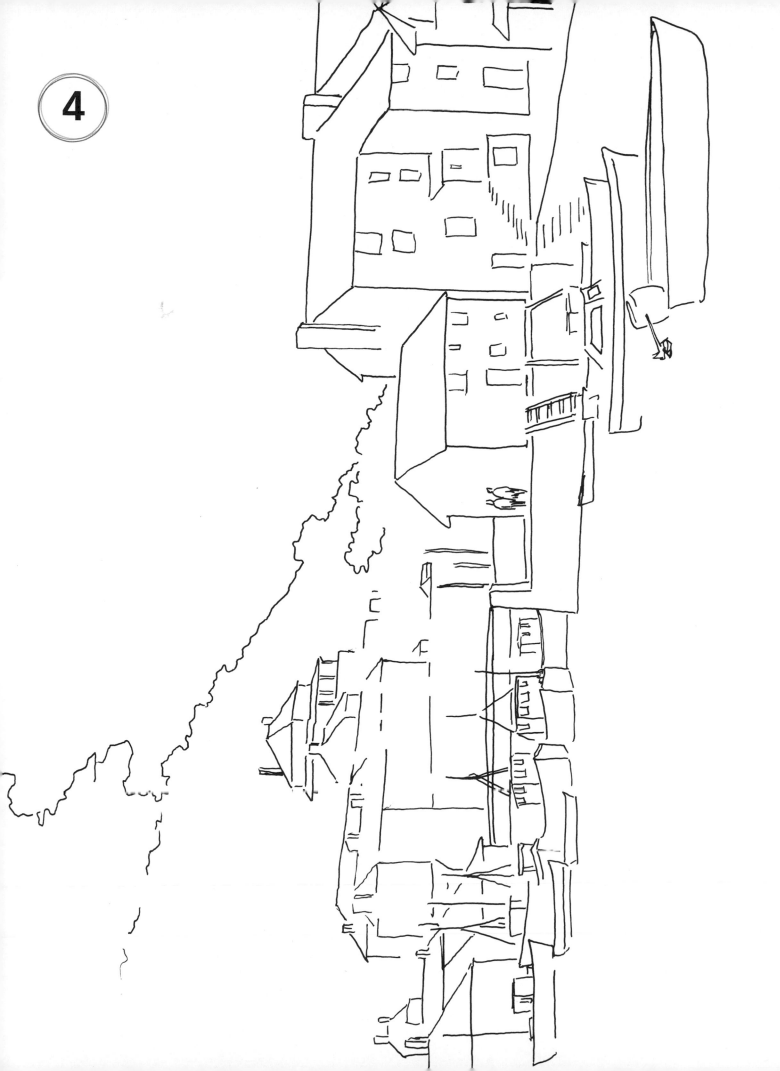

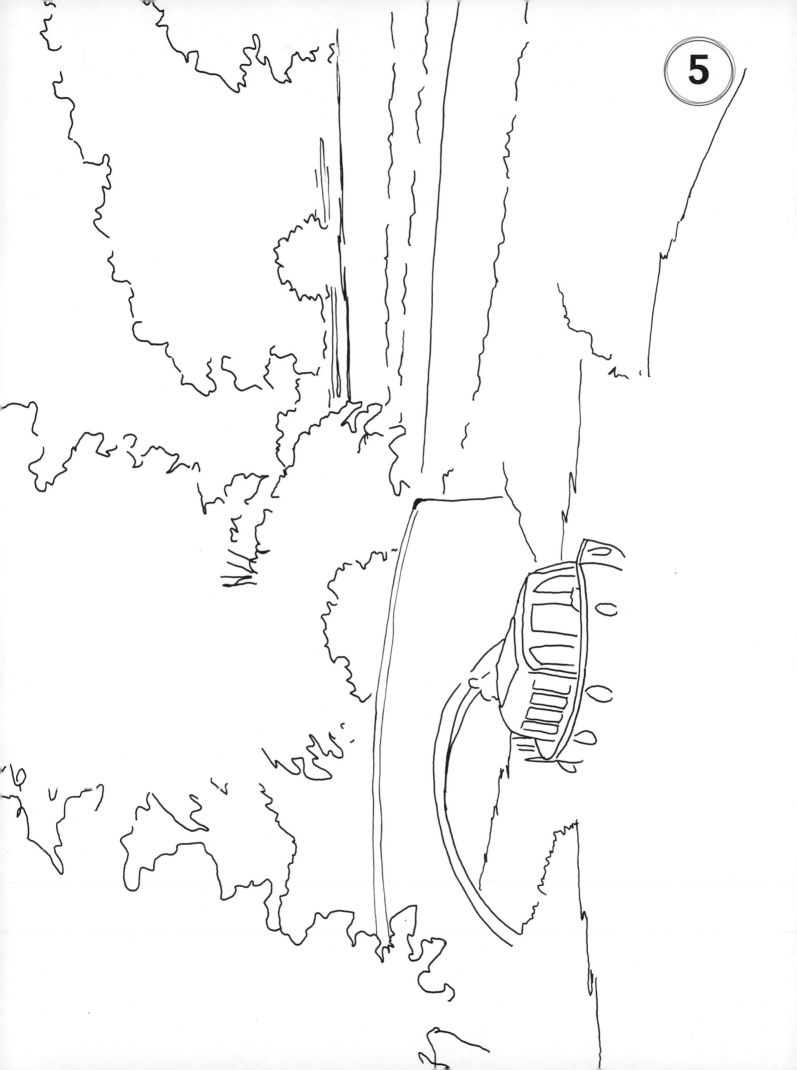

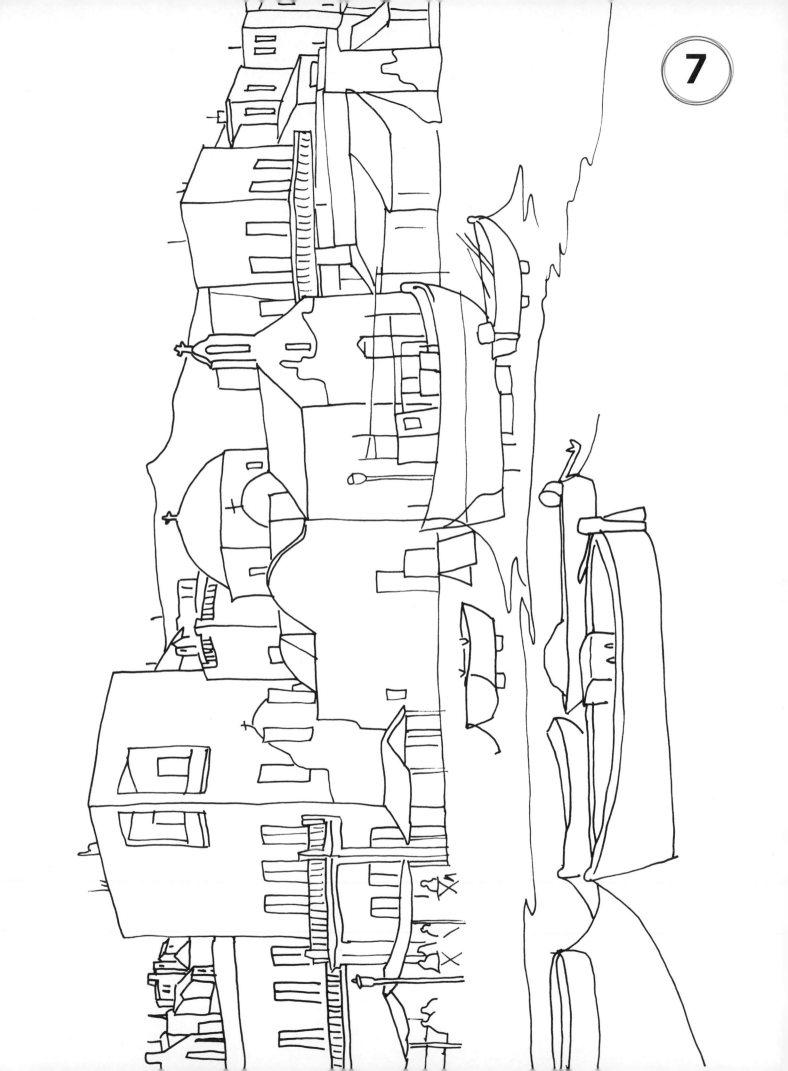

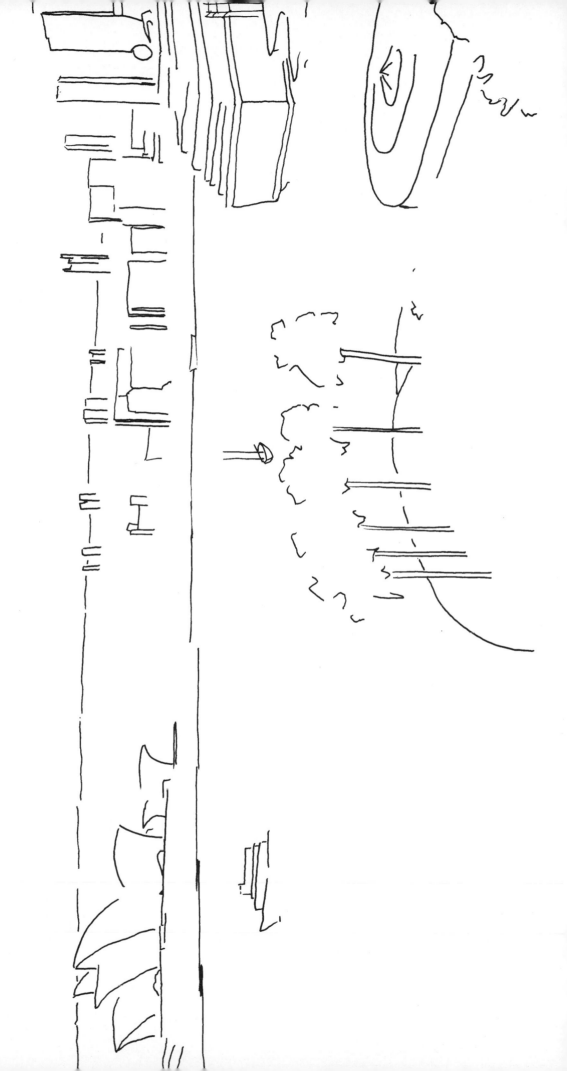

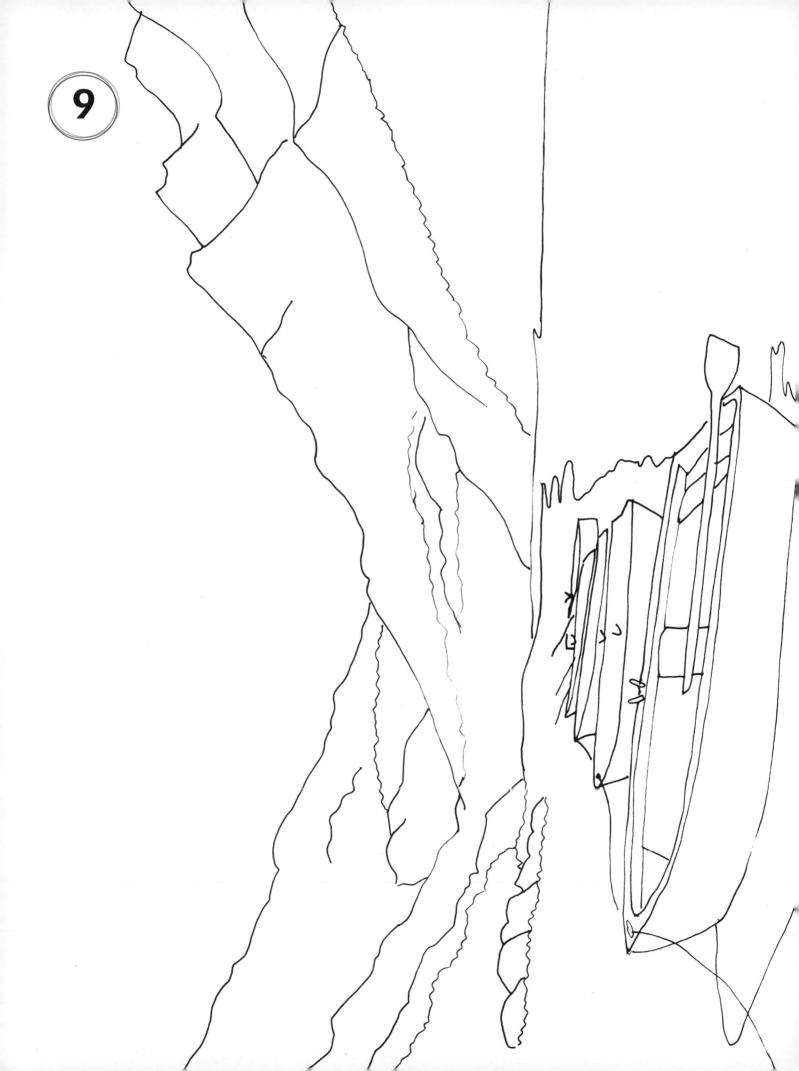

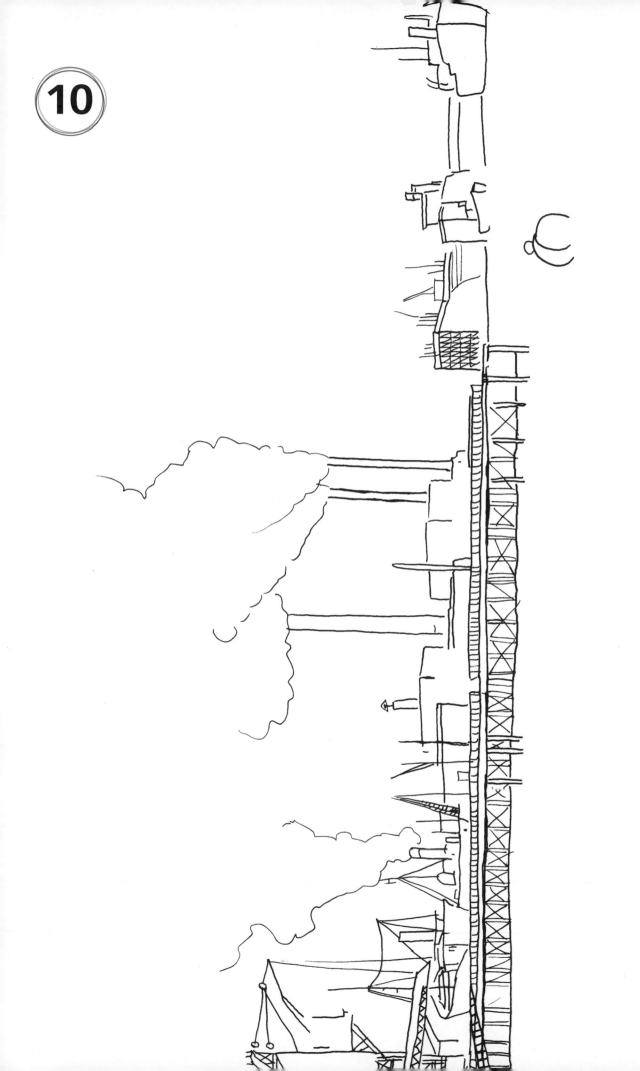

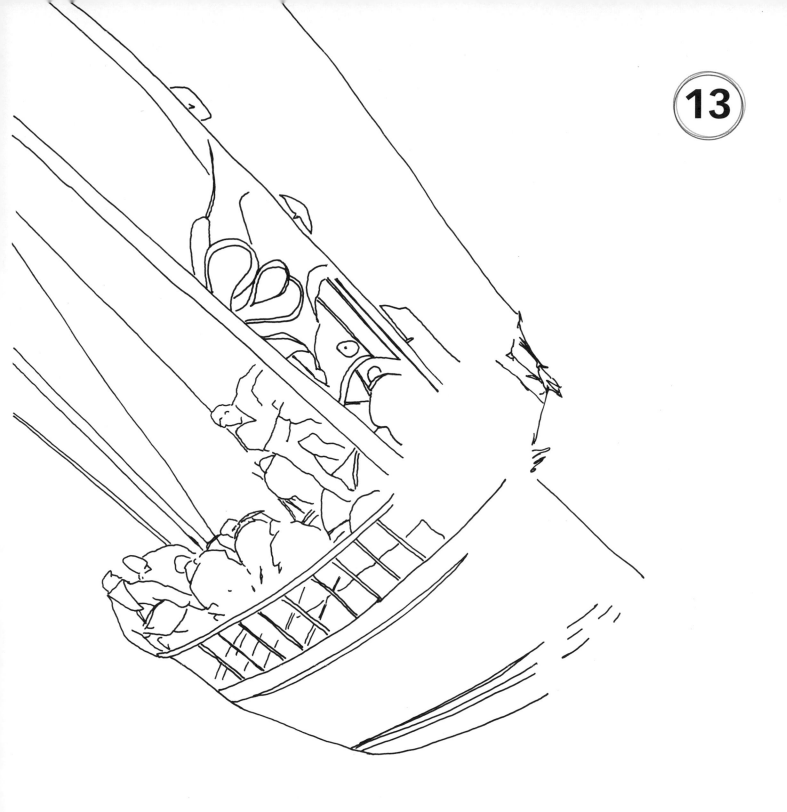

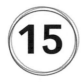

15

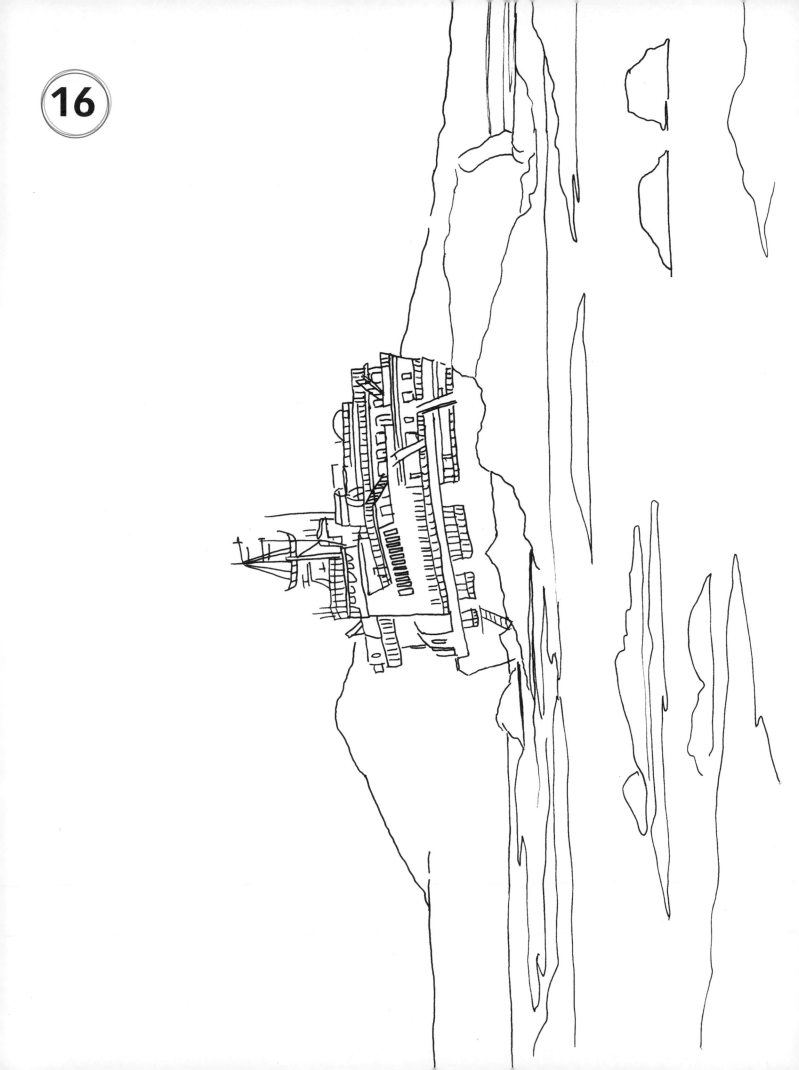

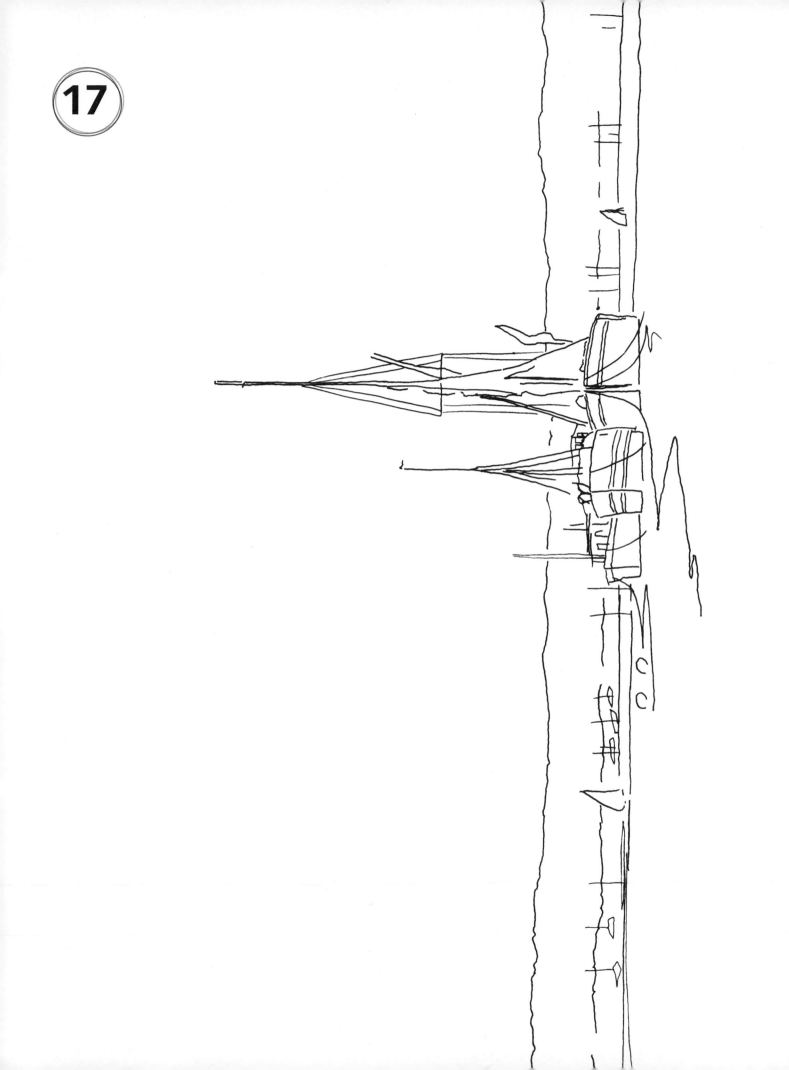

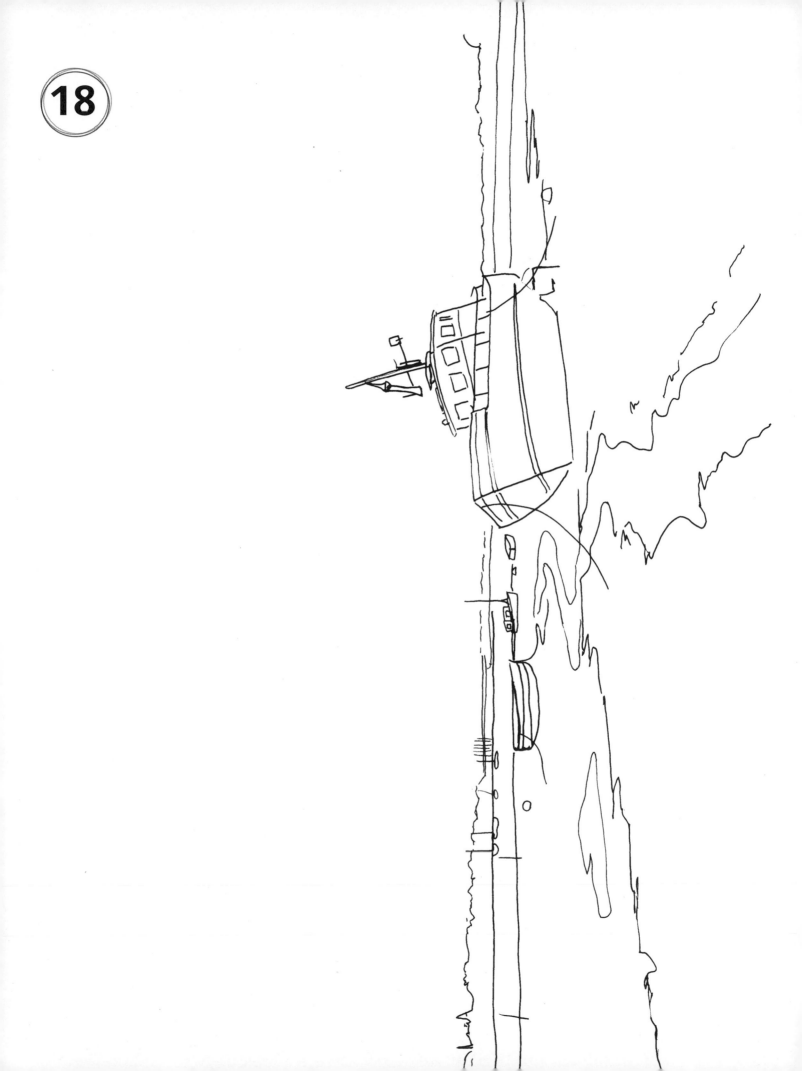

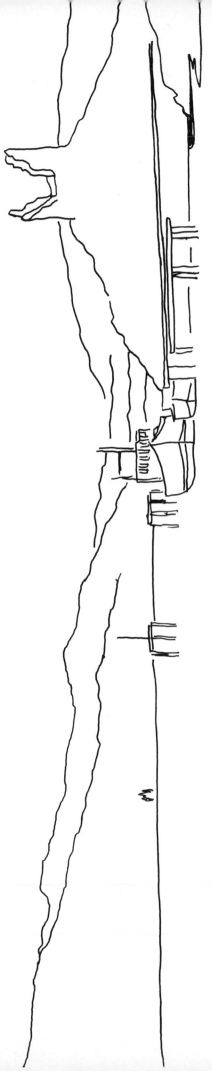

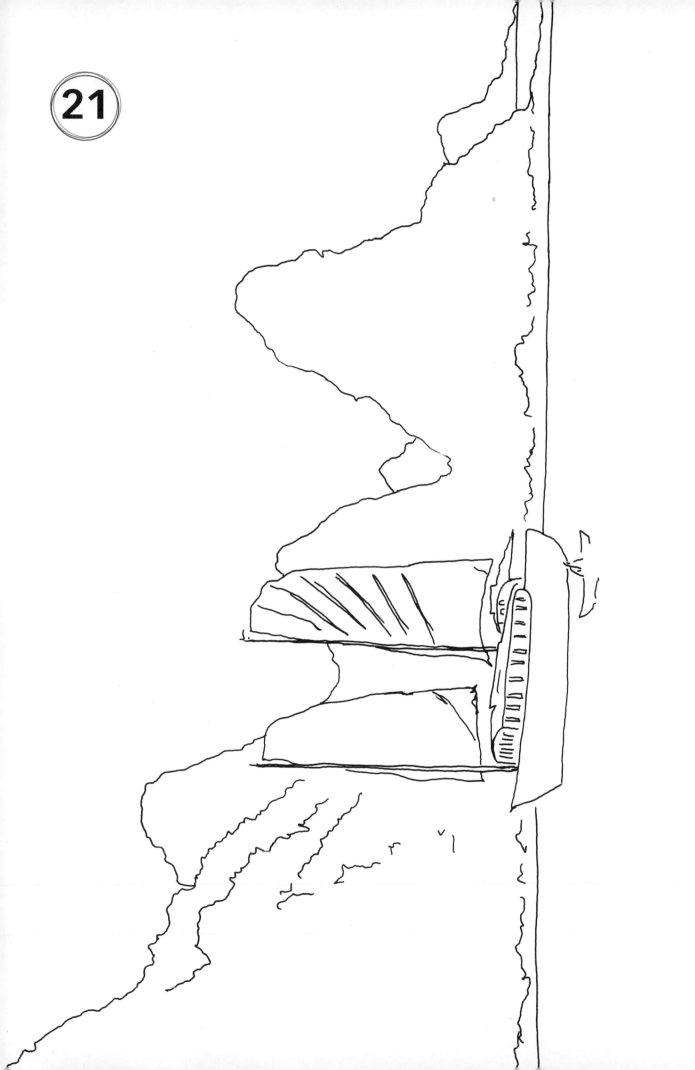

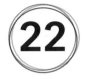

23

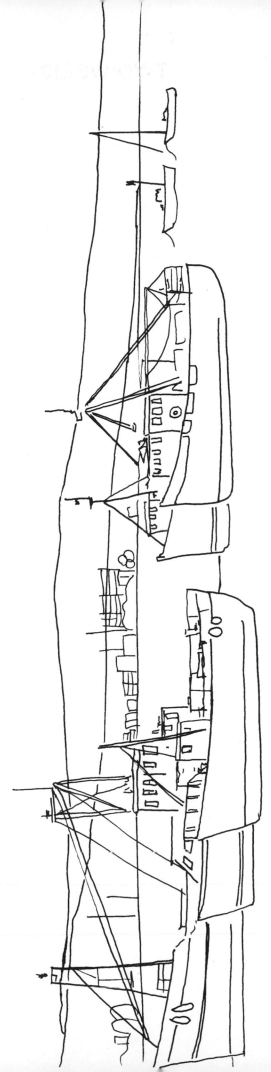